EBBW VALE
THROUGH TIME
Alan Davies-Tudgay

To AVRIL

Enjoy the Memories

Love & Best Wishes

Alan D. Tudgay

AMBERLEY PUBLISHING

November 1st 2012

Acknowledgements

I would like to record my grateful thanks to all the local people who have loaned photographs and helped in many ways to enable me to compile this glimpse of part of Ebbw Vale Town Development over the years, especially from the 1950s to 2010.

The Ebbw Vale Works Archival Trust – Brian Baker, Barrie Caswell, Eric Davies, Noel Evans, Norman Excell, Terry Hooper, the late John Gaydon, Ivor Lapham, Les Pinney, Howard Robinson and Mel Warrender – for permission to use photographs from their extensive library.

Mrs Linda Powell for typing all manuscripts and proofreading all text details. Dennis Jones for his enthusiastic support and help in providing postcard-size prints of all work considered before the final selection and compilation.

Photographs: Jack Baker, Margaret Blackwell (for allowing me the use of her Cwm photographs), Dilwyn Byles, Anthony & Wendy Cordingly, Allan Davies, Dwynwen Davies, Gerald Davies, Ken Davies, Gary Howells, Dennis Jones, the late John Jones, Mary Langford, Thelma Lawrence, Ivor Lewis, Diane Markey, Terry Meyrick, Glyn Morris, Ceri Owen, Fred Pettican, Ian & Linda Powell, the late Richard Seddon, Mike Sheppard, Terry & Shirley Shorthouse, Eric Smith, the late David Williams, and Sue Williams.

The following books were invaluable: *A Picture Book of Cwm* Vols 1–2 by Margaret Blackwell, *Ebbw Vale: The Works* by John Gaydon, Barrie Caswell and Mel Warrender, *A History of Ebbw Vale* by Arthur Gray-Jones, *Old Ebbw Vale in Photographs* Vols 1–7 by Keith Thomas, *Then and Now: Ebbw Vale* by Idwal Williams and *Images of Wales: Ebbw Vale* by Idwal Williams.

I would like to dedicate this book to my late mother, Mrs Ruth Davies-Tudgay, who was a lifelong inspiration to me.

Front cover top: A general view of the valley, 1969, shows Ebbw Vale Steelworks in full production.
Front cover bottom: A northerly view taken from the Drysiog mountain gate, 2010.

First published 2011

Amberley Publishing
The Hill, Stroud
Gloucestershire GL5 4EP

www.amberleybooks.com

Copyright © Alan Davies-Tudgay 2011

The right of Alan Davies-Tudgay to be identified as the Author of this work has been asserted in accordance with the Copyrights, Designs and Patents Act 1988.

ISBN 978-1-4456-0036-9

British Library Cataloguing in Publication Data.

A catalogue record for this book is available from the British Library.

Typeset in 9.5pt on 12pt Celeste.
Typesetting by Amberley Publishing.
Printed in the UK.

Introduction

In the mid-1700s the Upper Ebbw Fawr Valley was a rural district with numerous smallholdings and scattered farms situated around the upland landscapes. The valley and land lying to the north was divided into four parishes. To the north-west lay the parish of Llangynidr (comprising Rassau); to the north-east Llangattock parish (Beaufort and Garnlydan); to the south-west Bedwellty parish (the town of Ebbw Vale, Garden City and Victoria); and to the south-east the parish of Aberystruth (Newtown, Tyllwyn, Waunlwyd and Cwm).

Towards the end of the eighteenth century the landscape changed dramatically with the advent of industrialisation. Because of the unique geology of the area, the basic raw materials of iron making, namely iron ore, limestone, coal and a plentiful supply of water, attracted the attention of the early ironmasters. Large tracts of land that had hitherto been farmed were therefore purchased or leased from the farming community.

Beaufort Iron Works was established in 1780 by the Kendall family. The first furnace at Ebbw Vale was built in 1790 on the land of Pen-y-Cae Farm. The undertaking was expanded further by the Harford Partnership of Bristol, which had a profound influence on the town, and under its guidance the business flourished and the township of Ebbw Vale gradually grew with it. Workers had to be accommodated, so residential communities sprung up around the works: Newtown (c. 1820); Victoria (1837); Churchtown (c. 1840); Tyllwyn (1870s); Chapeltown (1880s); Waunlwyd (1890s); Cwm (c. 1900); Garden City (1918); Rassau and Beaufort (1800s); Hilltop and Garnlydan (c. 1950). The Abraham Darby Partnership bought the Harford Works in 1844 and also maintained its close links with the town and supervised the welfare of its workforce. The town and works prospered.

However, a reliance on coal mining and steel making was to have dire consequences for the town in the first quarter of the twentieth century. After a state of full employment at the end of the First World War, there was a series of disastrous strikes in the coal industry in 1921 and 1926 and a downturn in iron and steel demand in Europe, which led to mass unemployment. The works shut down its operations in 1929 and steelworkers were laid off as the depression cut deeply into the valley towns. Ebbw Vale was badly affected; the Government described the area as one of the worst economic black spots in the UK.

The salvation for the town came in 1936 when Richard Thomas & Co., under the chairmanship of Sir William Firth, bought the old works and modernised it. He introduced the continuous rolling processes that had been developed with great success in the USA, thereby establishing Ebbw Vale's as the first and largest integrated steelworks in Europe. Following the end of the Second World War, the Ebbw Vale works was regarded as the flagship of the British Iron and Steel Industry with a workforce rising beyond 11,000 workers and with it prosperity for the town and its communities.

The prevailing world economic conditions at the end of the 1960s marked the beginning of a steady rationalisation programme of the British steel and coal industries. Ebbw Vale Works found itself part of the British Steel Corporation and the manufacturing processes of iron and

steel making were closed down at the works. Ebbw Vale operated afterwards as a 'finishing' plant, concentrating on galvanising and tinning processes.

In 1986, almost 150 acres of derelict land forming part of the former 'heavy end' south of the works was made available to the Blaenau Gwent Borough Council to host the 1992 National Garden Festival of Wales. It proved to be a resounding success and its legacy to the town is much in evidence today, with the location of a new shopping mall at Festival Park and modern residential accommodation.

When the works finally closed in 2002 – by then trading as Corus Packaging Plus – fewer than 1,000 workers were employed there. All coal mining activity had ended with the closure of the Marine pit in 1989. Industrial estates were established at Cwm Draw, Newtown (1969), Rassau and Tafarnaubach (c. 1972) to mitigate, to some extent, the problem of unemployment. Superstores were established on the periphery of the town, but at the expense of the town's traditional shops. The cinemas had gone and people travelled more in search of their entertainment and, of course, to find employment outside the area. This was assisted greatly by the reintroduction of a new passenger railway link from Ebbw Vale Parkway to Cardiff Central in February 2008, forty-six years after the passenger service had been axed. This has proved to be an outstanding success.

Following the closure of the works in 2002, a demolition programme removed all evidence of the works except the former General Offices building, which was left intact, and this will be used as a Heads of the Valleys visitor centre. The site is the subject of a regeneration scheme, initiated by the borough, that will develop the land for a variety of recreational, educational and cultural pursuits, as well as provide opportunities for private housing and business projects. Latterly, the Borough has successfully hosted the 2010 National Eisteddfod of Wales on the site after an absence of fifty-two years, and in October 2010 the new hospital, Ysbyty Aneurin Bevan, was opened. In 2011 these projects will hopefully signal a new era in the fortunes of Ebbw Vale.

1. CWM

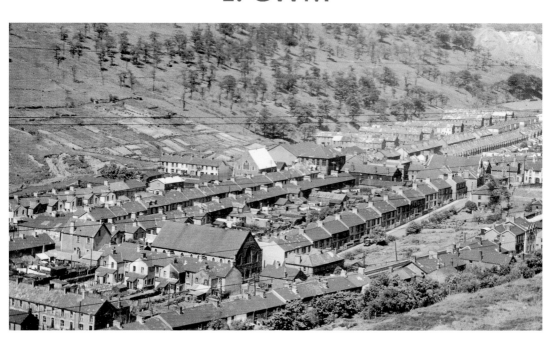

Cwm – General View (I)
A northerly view of Cwm in 1948. The Primitive Methodist Church is in the foreground. Today the same view shows the bypass that was built in 2004 along the same route as the Great Western Railway line to Newport.

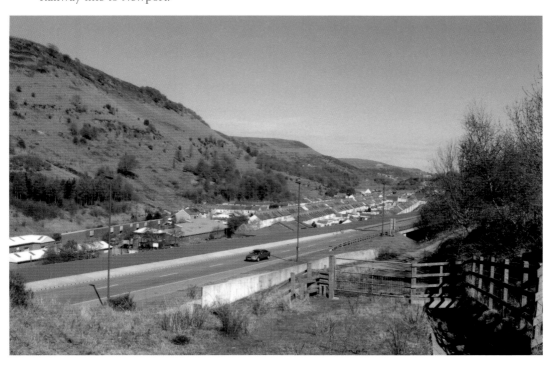

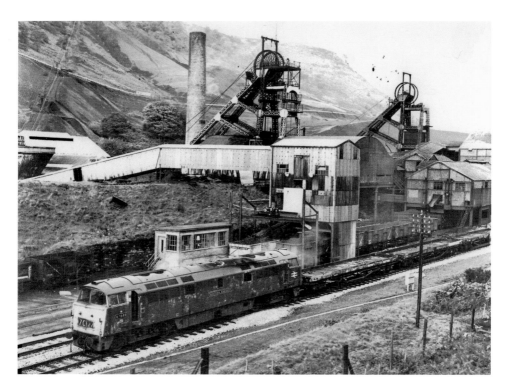

Cwm Marine Colliery

The Cwm Marine Colliery in full production; shafts were sunk in 1888, the date on the chimney. There was a major disaster on 1 March 1927 when an underground explosion made national news and fifty-two miners lost their lives. The opposite view, from the Rhiw Mountain Road to Manmoel, shows the colliery after closure in 1989. Today, the colliery shafts are capped.

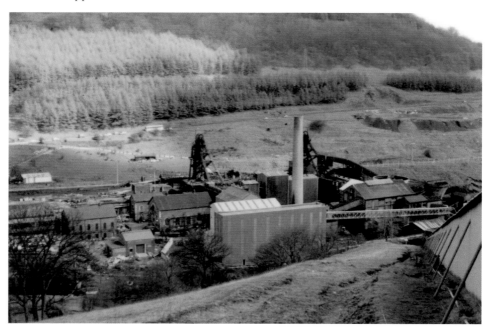

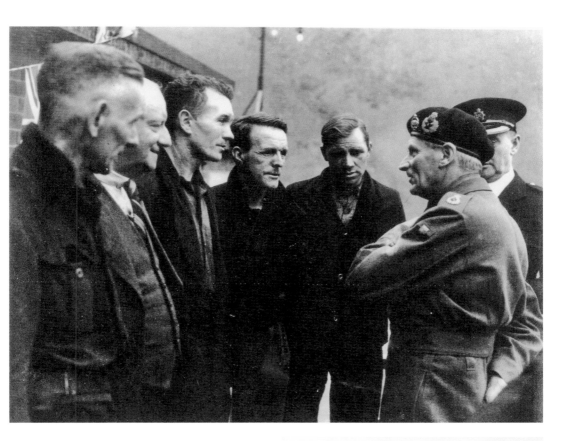

Visitors

Field Marshal Bernard Montgomery, 1st Viscount Montgomery of Alamein, KG, GCB, DSO, visits the Marine Colliery on 23 September 1948. Lewis Baker, chairman of the Welsh Quoiting Association, is pictured second from the left. Dai Davies, MP for Blaenau Gwent (2006–10), unveiled the statue of a miner on 27 February 2009 in the Miners' Memorial Garden. The funds were raised locally by Cwm Community Care. The inscription reads, 'In memory of the men that worked and lost their lives in the Ebbw Fawr Mining Industry'. Two tablets are inscribed with poems written at Cwm and Waunlwyd junior schools. Cwm Junior School pupils are in the photograph.

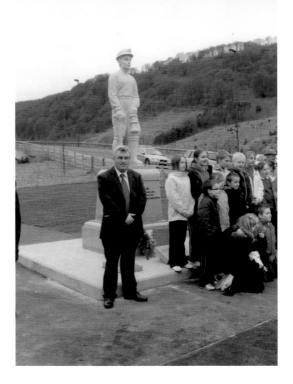

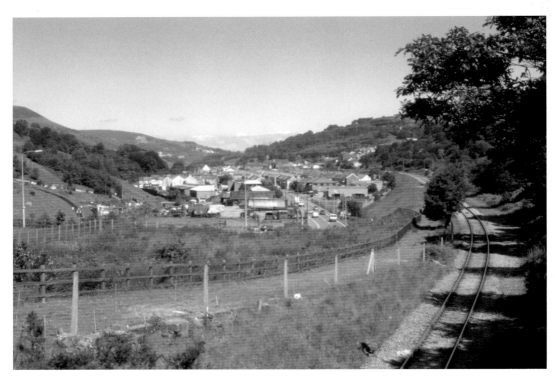

Cwm – General View (II)
The view north from Waterloo Terrace shows the single-track GWR line. Today's view shows the new elevated Cwm bypass, which follows the old rail track.

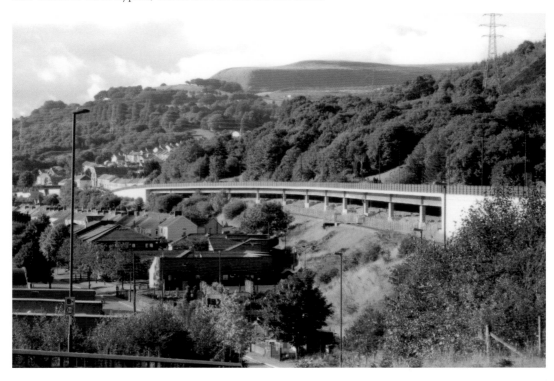

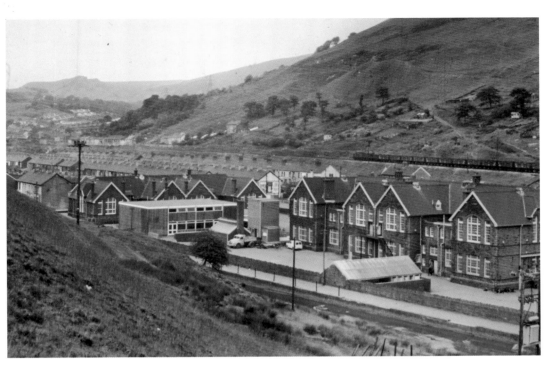

Cwm Schools
Dyffryn Secondary Modern School, along with the junior and infant schools, in 1964. The demolition in the 1970s followed the school's closure in 1975. These schools were situated directly under Cwm Tips; fears were raised that a similar disaster to that of Aberfan in 1966 would occur.

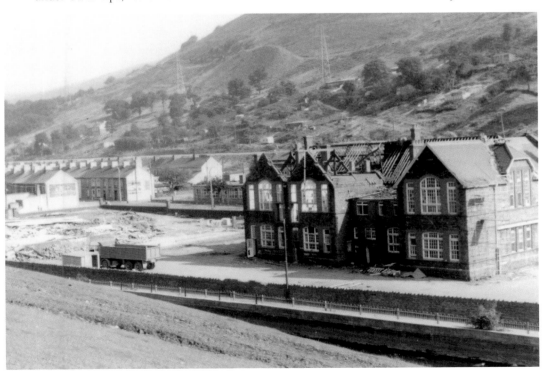

Cwm Choir

The famous Cwm Dyffryn School Choir, winners of ITV's *Opportunity Knocks* in 1957. Its conductor, Patrick Sheen, was awarded an MBE in October 1993 for his services to music. Industrial units are on the site today.

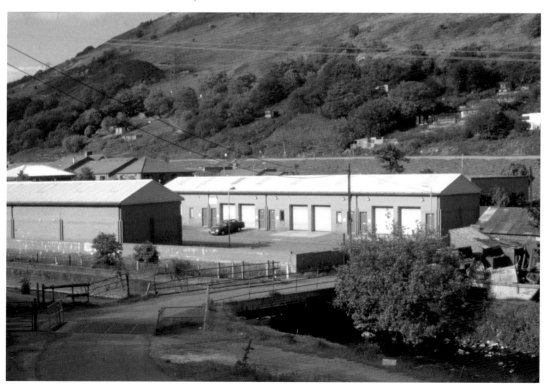

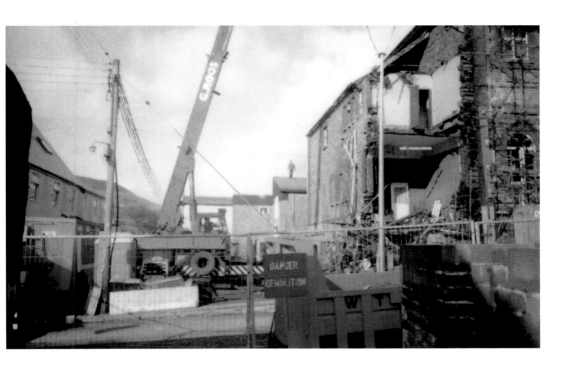

Canning Street, Cwm

Cwm Institute was cordoned off in the process of restoration on 13 February 1992. However, the building collapsed, sadly with one fatality. The new institute was built in 1995 on the same site, next to the existing Cwm Library.

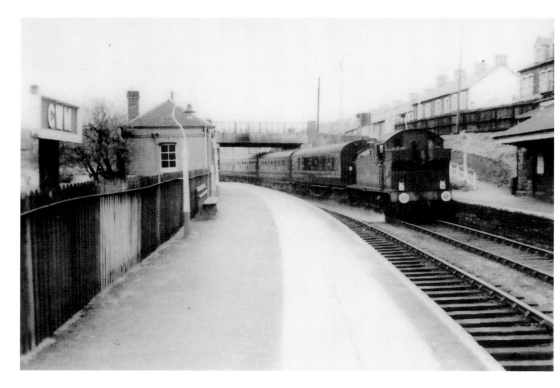

Cwm Bridge

A miners' train at Cwm railway station, which closed in 1962. The route is now the new bypass. Below, the new bridge is being constructed over the bypass. Station Terrace is in the background.

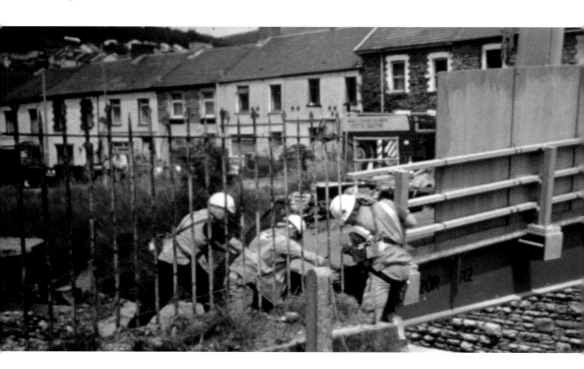

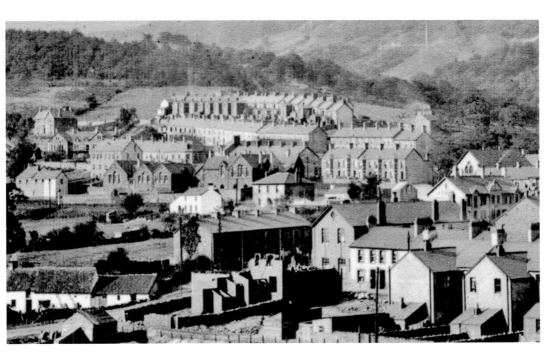

Cwm Junior School
A 1905 photograph by local photographer John Lloyd, who documented the growth of Cwm in the early 1900s. It shows Cwmyrdderch School, since replaced with flats. Mill Terrace Methodist Church is due to be demolished owing to structural problems.

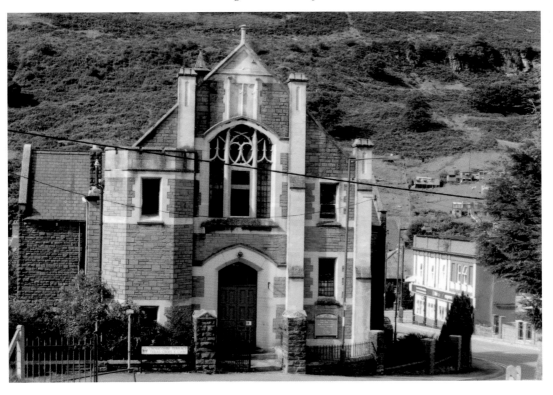

Café and Public Houses
Buildings demolished in 2000: the Royal Oak, Louis Café and the St John Ambulance Hall, which is next to Tirzah Church, Station Terrace.

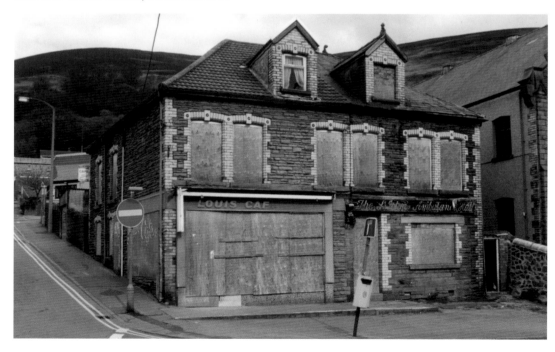

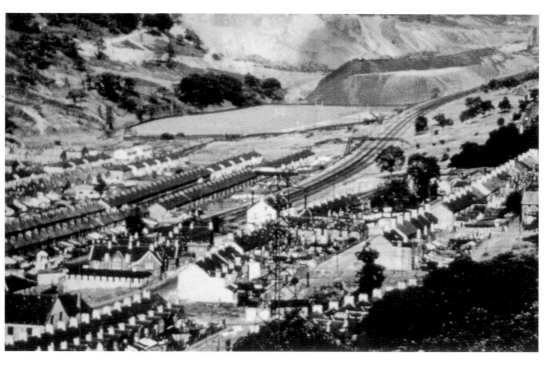

Cwm – General View (III)
A view north in the 1950s shows Cwm, Betterment Field, the GWR line, the old footbridge, Cwmyrdderch School and Waunlwyd Tips. The view of 2008 shows Betterment Field, New Road, the new footbridge, and the Festival Park shopping outlet.

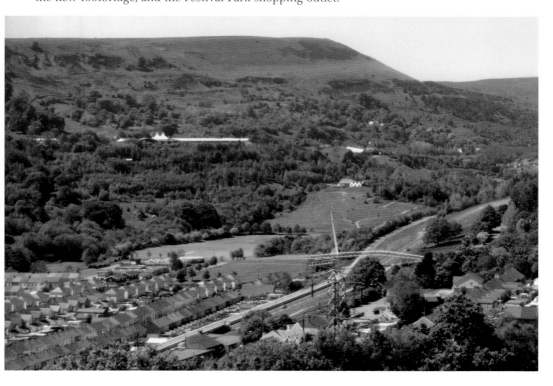

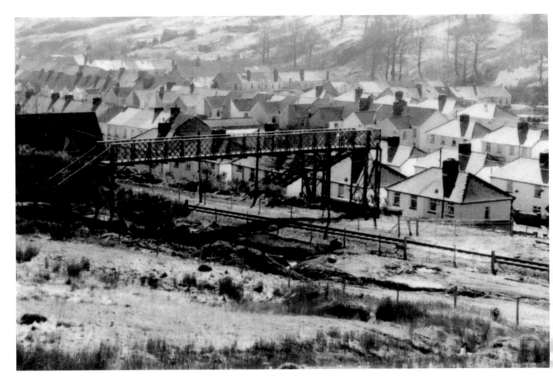

Footbridges

The old footbridge over the GWR line north of Cwm. Below, the old and new footbridges, plus Cwm Primary School, in 2004. The new school was re-sited from the old site at Dyffryn; it was built and opened in 1972.

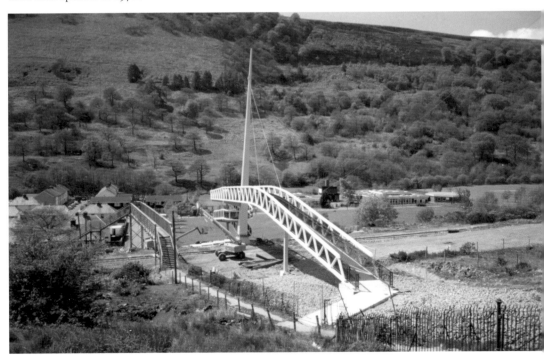

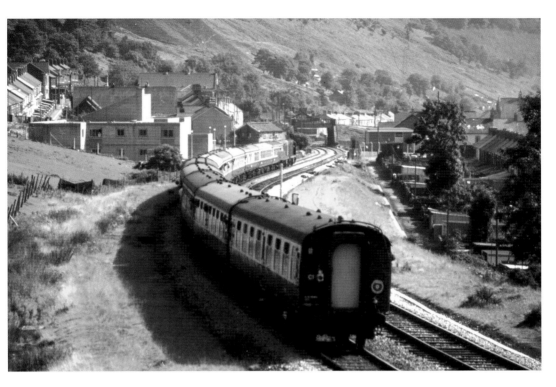

Rail and Road (I)

A southerly view of Cwm, with flats on the site of old Cwmyrdderch School on the left. A rail special can be seen from the old footbridge. Today's view from the new footbridge shows the new rail link to Cardiff, opened on 6 February 2008, and the Cwm bypass, built in 2004.

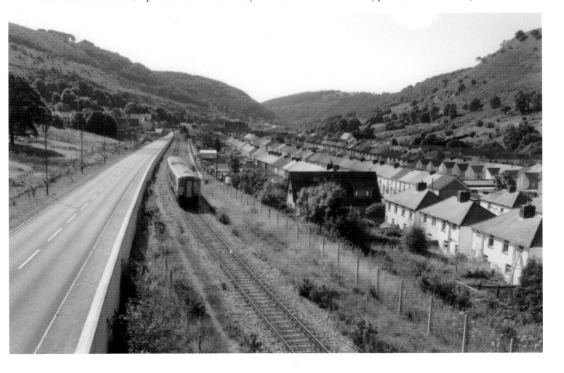

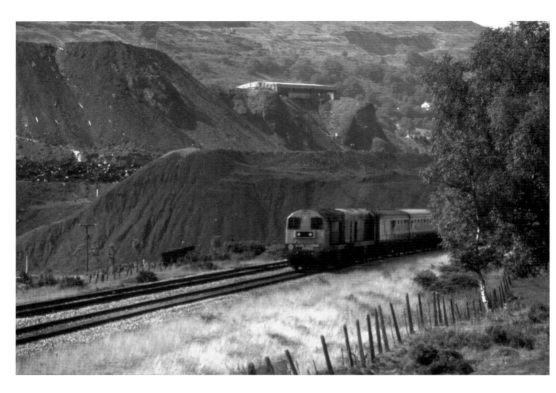

Rail and Road (II)

The view north from the old footbridge shows Waunlwyd Tips and a rail special. Today's view is of the new rail link, the Cwm bypass, and the Festival Park shopping site.

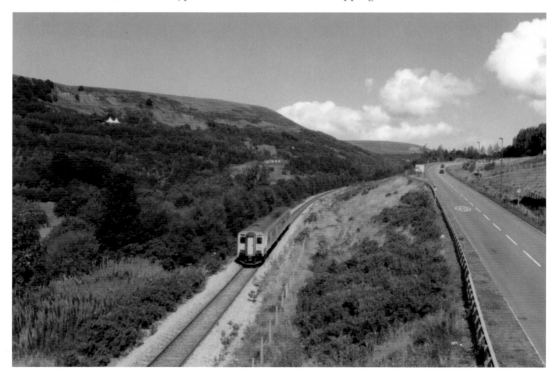

2. WAUNLWYD

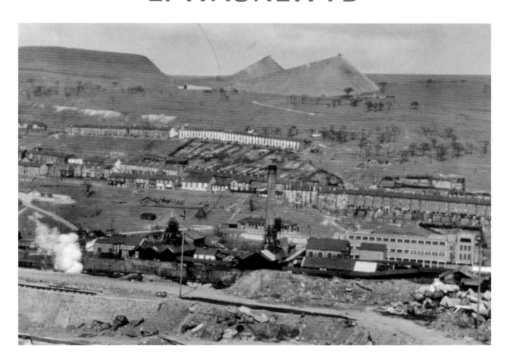

Waunlwyd

Two pyramids of spoil and waste from Ebbw Vale Steelworks dominate the north-easterly view of Waunlwyd in April 1954. The view in 2010 shows new housing on the Garden Festival site. The tips are levelled; they have been superseded by the Silent Valley disposal site.

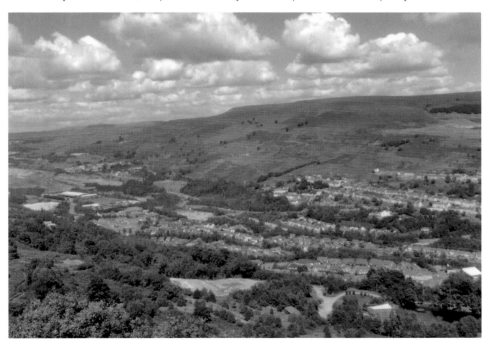

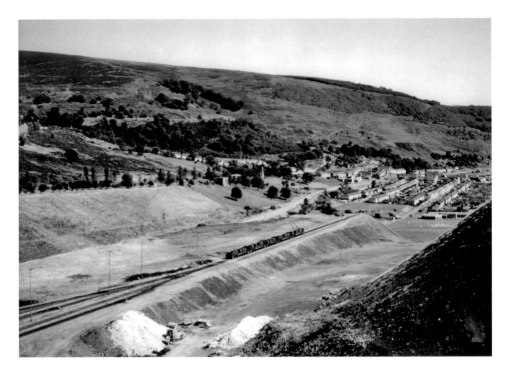

South to Cwm

The view south to Cwm from Waunlwyd Tips in August 1986 shows the rail sidings. The same viewpoint illustrates the area's transformation for the National Garden Festival of Wales, held from 1 May to 4 October 1992. The announcement that the Garden Festival of Wales would come to Ebbw Vale was made in 1986; it was the fifth and last National Garden Festival.

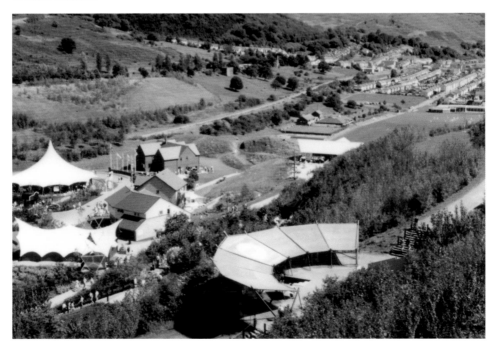

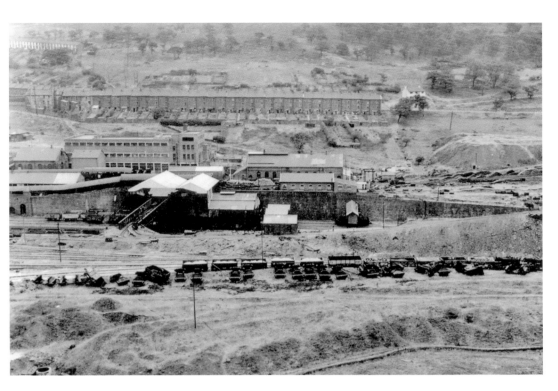

Waunlwyd – Panorama (I)

A view across to Waunlwyd Colliery and Cwm Road in August 1955. Today the Coed-y-Garn housing is on the colliery site. The lakes remained after the National Garden Festival closed.

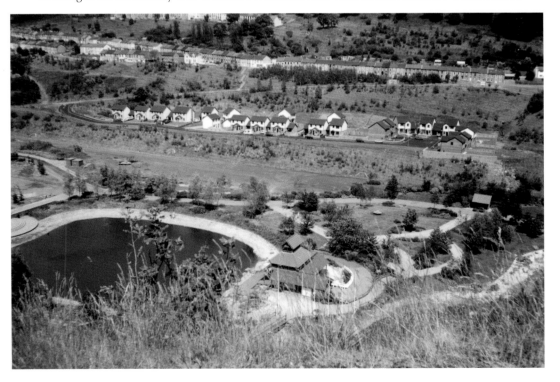

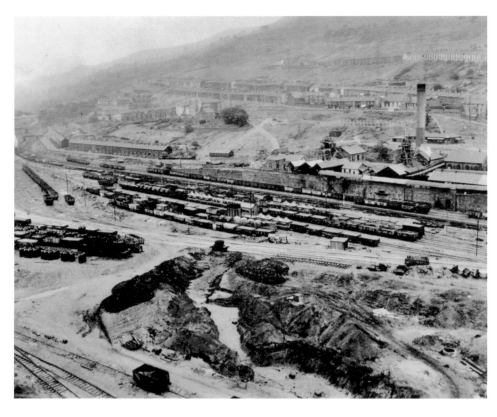

Waunlwyd – Panorama (II)
The railway sidings at the Ebbw Vale Steelworks and Waunlwyd Colliery in 1955. A similar view was taken during the 1992 National Garden Festival.

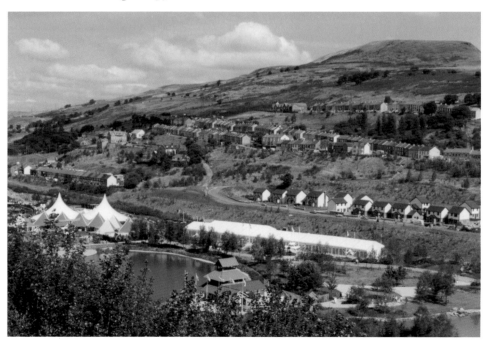

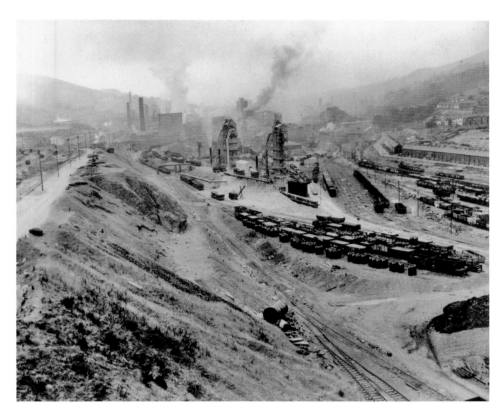

Waunlwyd – Panorama (III)

The view north to the lime-burning plant and Waunlwyd from the Hecketts Reclamation Company's site in 1955. In 1990, the National Garden Festival was held on the same site.

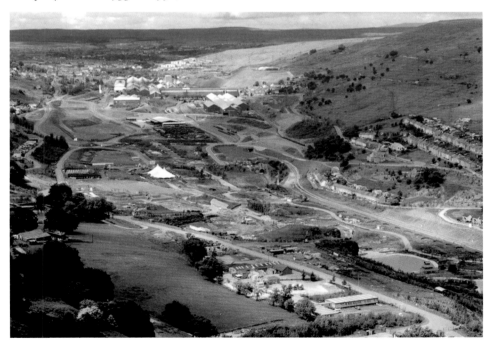

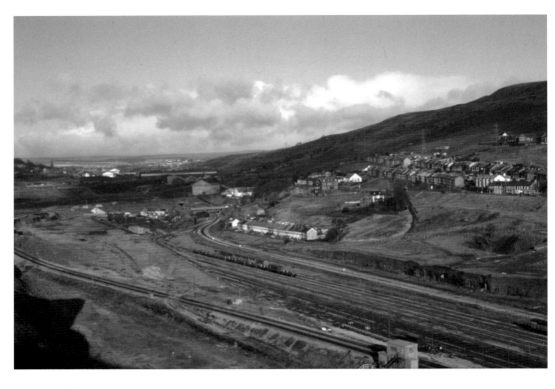

Railway Sidings
A northerly view of the railway sidings from 1986, after the heavy end of the steelworks was demolished. The 1992 view of the National Garden Festival site is from the Sky Shuttle.

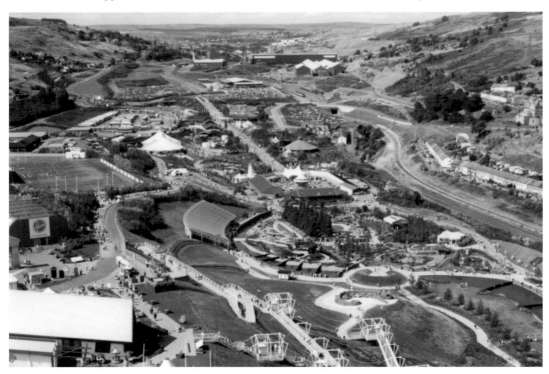

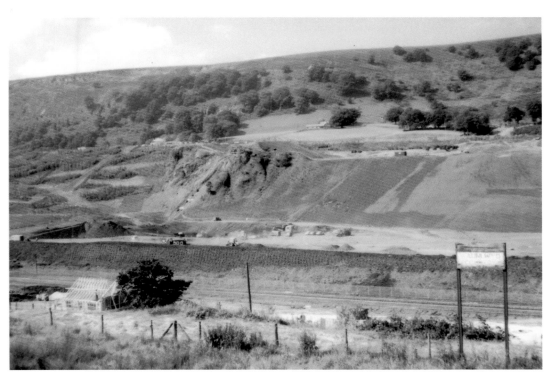

View from Waunlwyd

Another general view of the National Garden Festival site in 1990, together with the same view in 1992, when the festival was in full swing. Note the old Waunlwyd Colliery sign.

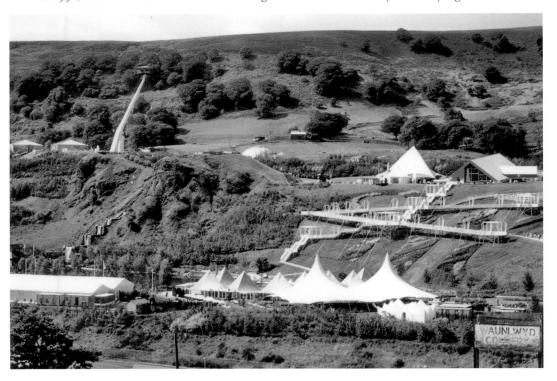

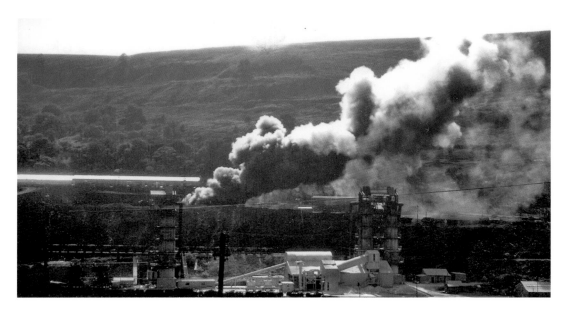

Pollution and a Festival
Lime plant and pollution in 1960s. Below, the National Garden Festival's rainbow of flowers and tropical plant house in 1992. What a transformation!

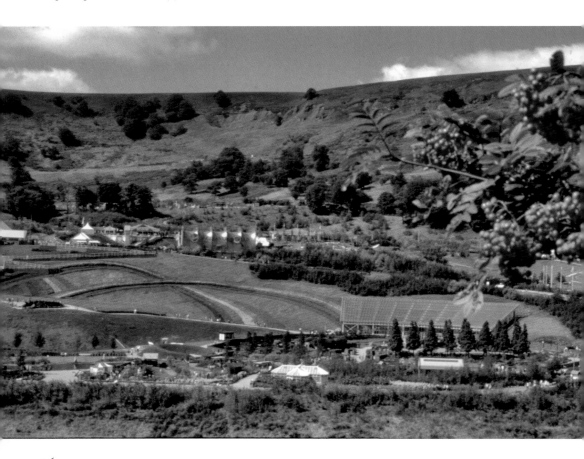

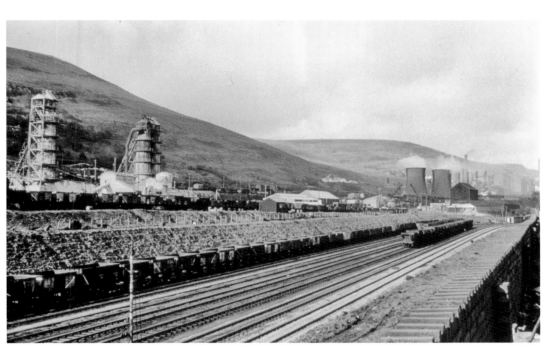

The Loss of Industry

The northerly view of Ebbw Vale Steelworks (heavy end), the railway sidings, the lime plant and the cooling towers in use in the 1960s. Below, the various attractions in 1992 for the Garden Festival of Wales.

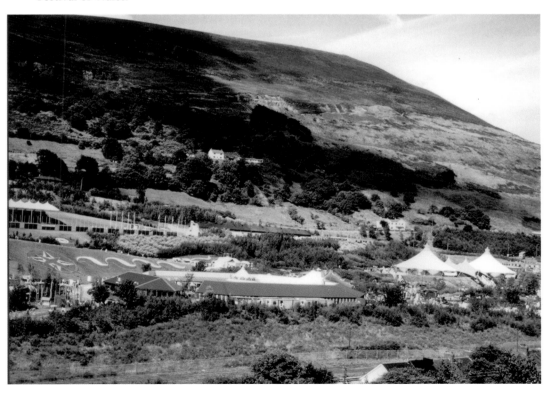

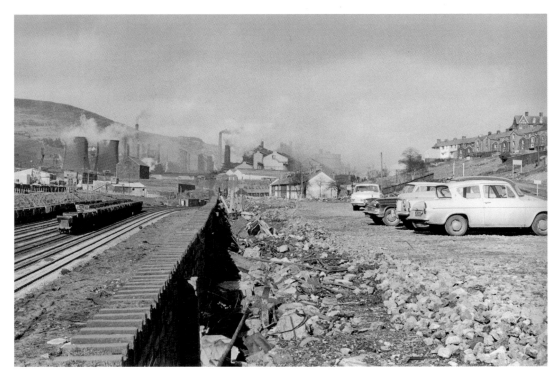

Replacing Industry

A northerly view from the old Waunlwyd Colliery in the 1960s (afterwards the site of Critchcraft, then Status), and the National Garden Festival view in 1992. The Park Hotel in Waunlwyd can be seen on the right of both photographs.

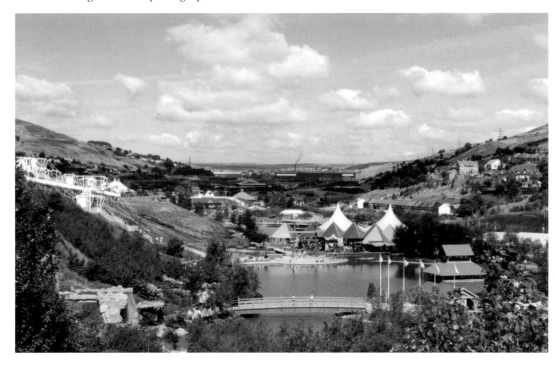

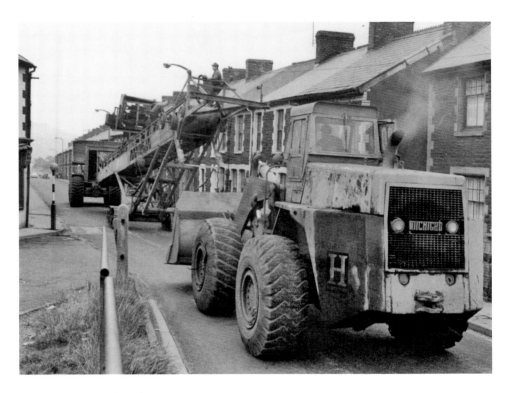

Cwm Road, Waunlwyd
A southerly view. A conveyor is being taken up to the Silent Valley Tips on the mountain above Waunlwyd in the 1960s. The houses on this side of Cwm Road were demolished for road-widening in 1975, as shown in the view north from the Waunlwyd Youth & Community Centre in 1992.

Old Farm
A painting of the old Pen-y-Crug Farm together with the farm's ruins in the shadow of the huge Silent Valley Tips, which were levelled to provide the base for the construction of the Llanwern Steelworks, Newport, in 1960.

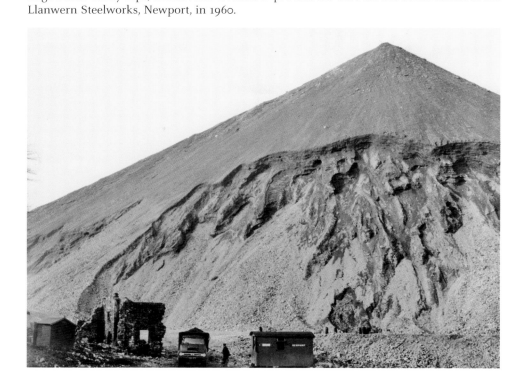

Park Place, Waunlwyd

A southerly 1982 view, after snowfall, of the Wesleyan Chapel, now demolished, with the Villas and Park Place shops. The northerly view shows Waunlwyd Post Office, which closed on 15 May 2004, together with the Park Place shops.

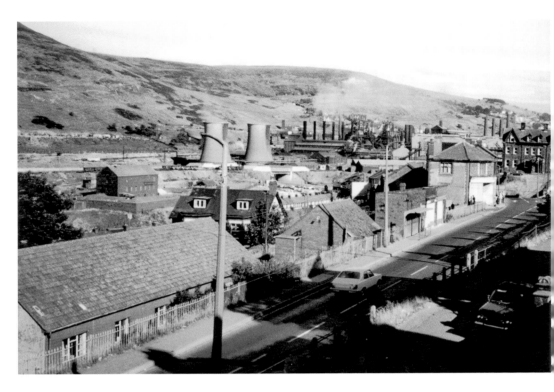

Waunlwyd Shops
The view north from Park Place in 1969 shows Ebbw Vale Steelworks, plus the Park Hotel. A similar view below shows the new Cwm Footbridge being delivered by road in 2004. Note the new housing estate on the old works site.

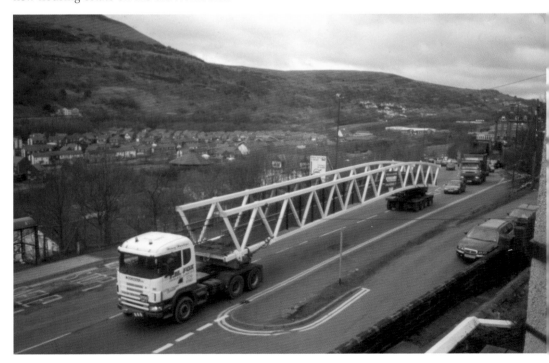

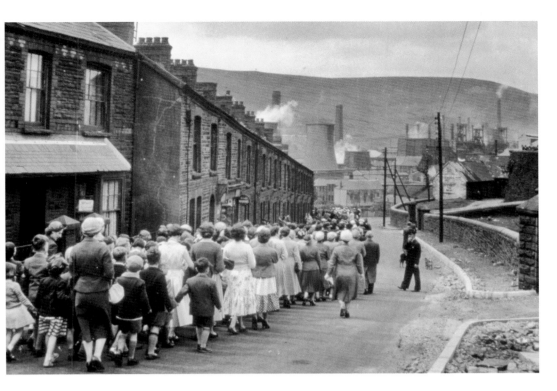

Whitsun Walk

Caersalem Church's Whitsun Walk (*c.* 1955) along Station Road *en route* to Ebbw Vale. Station Road was demolished for road improvements in 1975. The photograph below is the opposite direction; it was taken from the grounds of the Park Hotel today.

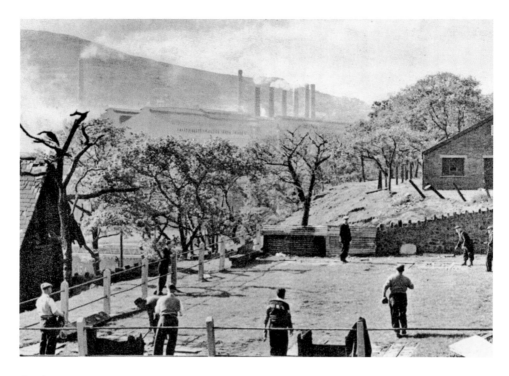

Quoits

The Park Hotel (built by Johannes and Winifred Yendoll in 1899) had an International Quoits pitch. This northerly view from the hotel shows the old ambulance hall. The last International, Wales *v*. Scotland, was played here on 21 June 1958; the result was Scotland 142–Wales 104. For many years Cwm, Waunlwyd, Victoria and Ebbw Vale produced quality International players.

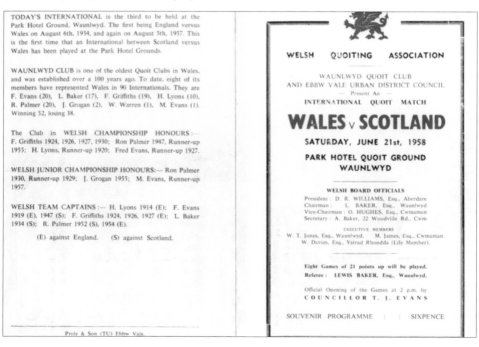

TODAY'S INTERNATIONAL is the third to be held at the Park Hotel Ground, Waunlwyd. The first being England versus Wales on August 6th, 1934, and again on August 5th, 1957. This is the first time that an International between Scotland versus Wales has been played at the Park Hotel Grounds.

WAUNLWYD CLUB is one of the oldest Quoit Clubs in Wales, and was established over a 100 years ago. To date, eight of its members have represented Wales in 90 Internationals. They are F. Evans (20), L. Baker (17), F. Griffiths (19), H. Lyons (10), R. Palmer (20), J. Grogan (2), W. Warren (1), M. Evans (1). Winning 52, losing 38.

The Club in WELSH CHAMPIONSHIP HONOURS :— F. Griffiths 1924, 1926, 1927, 1930; Ron Palmer 1947, Runner-up 1955; H. Lyons, Runner-up 1920; Fred Evans, Runner-up 1927.

WELSH JUNIOR CHAMPIONSHIP HONOURS:— Ron Palmer 1930, Runner-up 1929; J. Grogan 1955; M. Evans, Runner-up 1957.

WELSH TEAM CAPTAINS :— H. Lyons 1914 (E); F. Evans 1919 (E), 1947 (S); F. Griffiths 1924, 1926, 1927 (E); L. Baker 1934 (S); R. Palmer 1952 (S), 1954 (E).

(E) against England. (S) against Scotland.

Prole & Son (TU) Ebbw Vale.

WELSH QUOITING ASSOCIATION

WAUNLWYD QUOIT CLUB
AND EBBW VALE URBAN DISTRICT COUNCIL
— Present An —
INTERNATIONAL QUOIT MATCH

WALES v SCOTLAND

SATURDAY, JUNE 21st, 1958

PARK HOTEL QUOIT GROUND
WAUNLWYD

WELSH BOARD OFFICIALS
President : D. R. WILLIAMS, Esq., Aberdare
Chairman : L. BAKER, Esq., Waunlwyd
Vice-Chairman : O. HUGHES, Esq., Cwmaman
Secretary : A. Baker, 22 Woodville Rd., Cwm

EXECUTIVE MEMBERS
W. T. Jones, Esq., Waunlwyd. M. James, Esq., Cwmaman.
W. Davies, Esq., Ystrad Rhondda (Life Member).

Eight Games of 21 points up will be played.
Referee : LEWIS BAKER, Esq., Waunlwyd.

Official Opening of the Games at 2 p.m. by
COUNCILLOR T. J. EVANS

SOUVENIR PROGRAMME : : SIXPENCE

3. VICTORIA

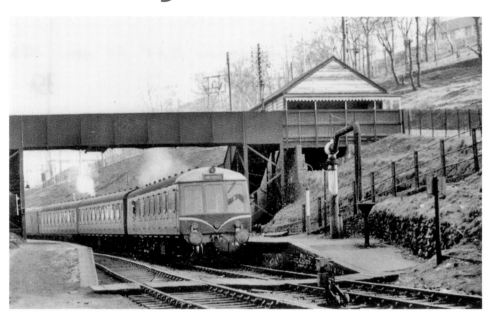

Victoria Station / Ebbw Vale Parkway Station

The last train at Victoria Station, Saturday 28 April 1962, before the GWR line was closed to passenger trains. However, the line did remain open for freight to Ebbw Vale Steelworks. After forty-six years the new passenger rail link to Cardiff opened on 6 February 2008 – an amazing success story. Usage has exceeded all expectations and continues to do so. The late Peter Law MP, also Assembly Member for Blaenau Gwent (2005–06), was the driving force in bringing this line back into use.

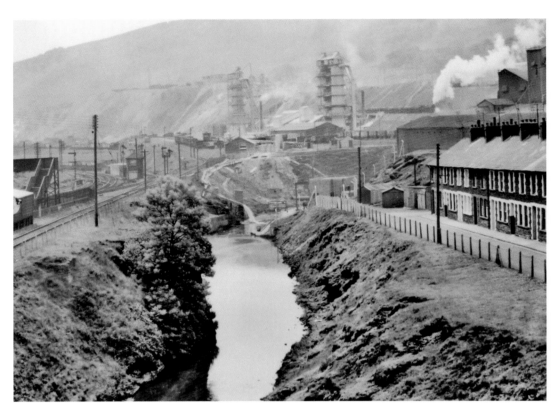

River Ebbw Fawr

The view south from the old footbridge over the River Ebbw by Glan Ebbw Terrace in the 1950s and again in 2002. Note the changes in the background view.

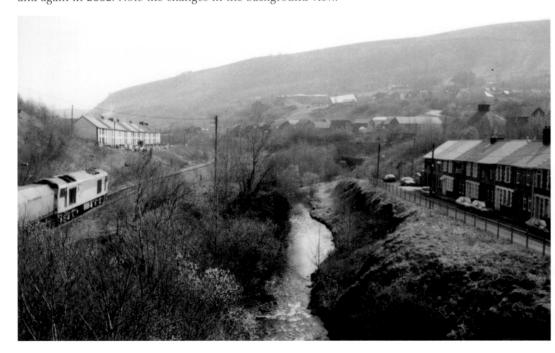

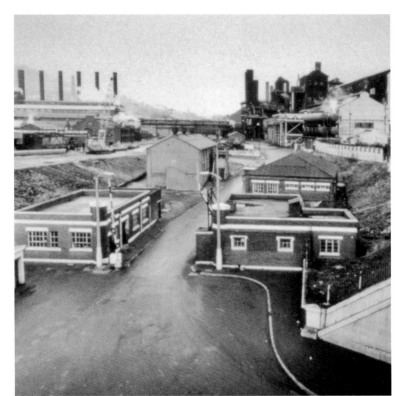

South Gate, Victoria
The huge Ebbw Vale Steelworks site had four workers' entrance gates. This is the south gate. Today it is the site of the Premier Inn and Victoria Park Brewers Fayre pub.

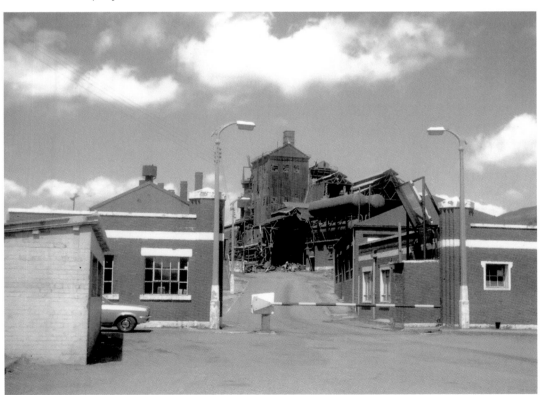

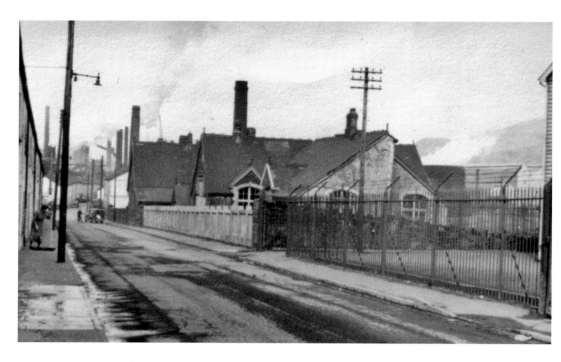

Queen Street, Victoria

A northerly 1958 view of Queen Street and Victoria School (RTB's apprentice school). Below, the view north from the new Victoria Heights housing development in 1999; the road leads out at the bottom of the picture to the Festival Park shops.

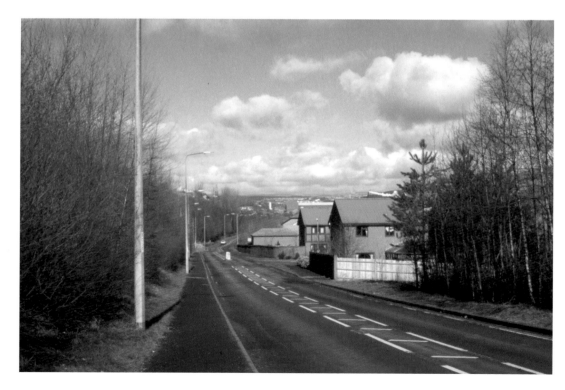

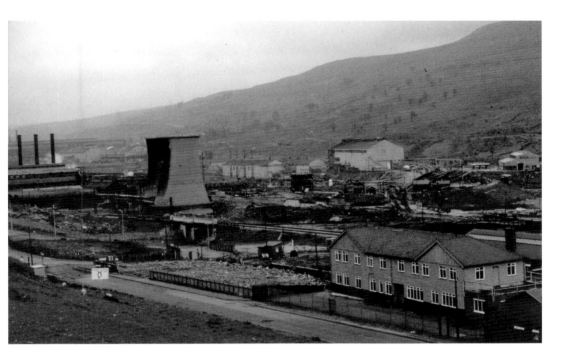

Apprentice Schools
A view across to Ebbw Vale Steelworks, the cooling towers and the apprentice school (formerly a hostel) in 1980. Victoria School was next to the apprentice school until it was demolished. The similar image below was taken in 1999 before the pickler end of the steelworks was finally closed and demolished.

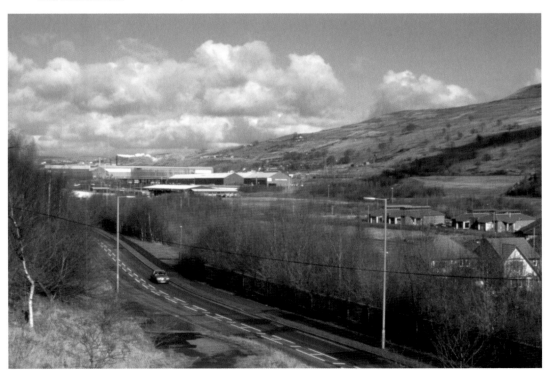

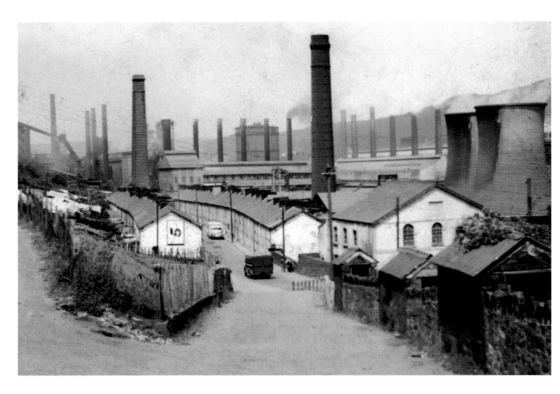

Augusta Street, Victoria

A rare colour photograph of Augusta Street, Victoria, in the 1950s, looking to the north. Bethel Chapel is pictured. The other photograph is of the old Victoria School (the apprentice school) in 1978, before demolition.

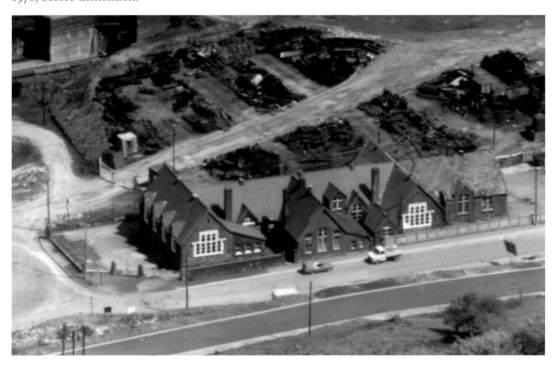

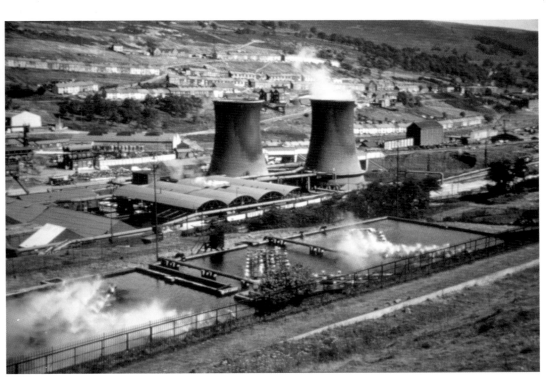

Water Treatment
A 1960s view south-east of the water treatment plant, the cooling towers and Waunlwyd beyond; plus a 1992 view of the new road and Waunlwyd.

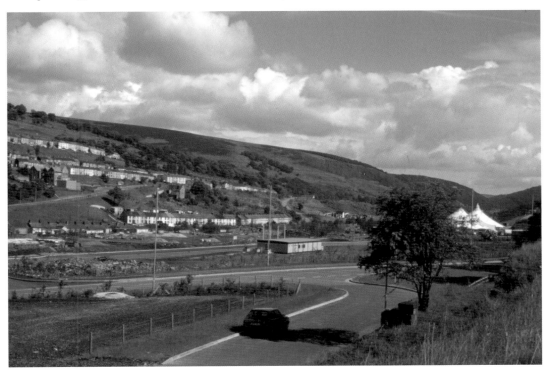

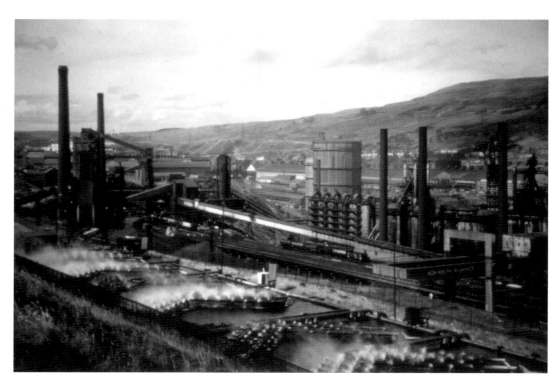

Ebbw Vale Steelworks
A 1960s view north-east of the water treatment plant and the heavy end of Ebbw Vale Steelworks, with a similar view in 1999.

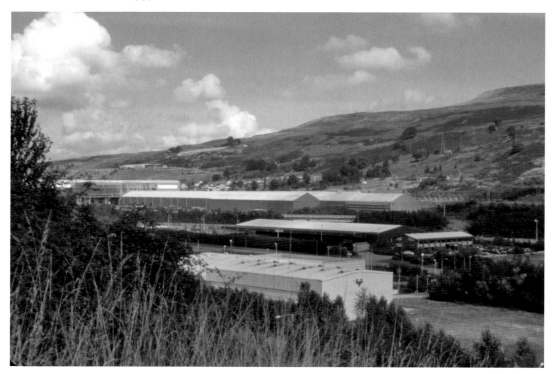

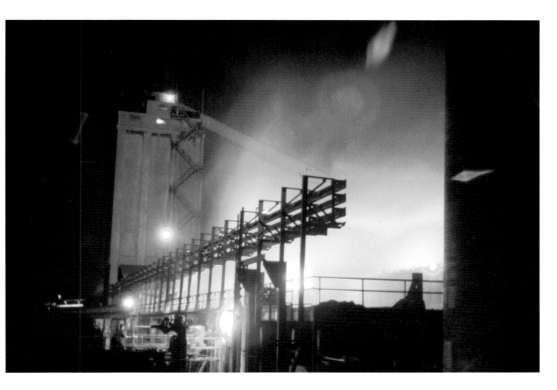

Red Sky at Night
The Coke Ovens in full operation in 1969 opposite Garden City. Below, a 1999 view from Garden City of the same area.

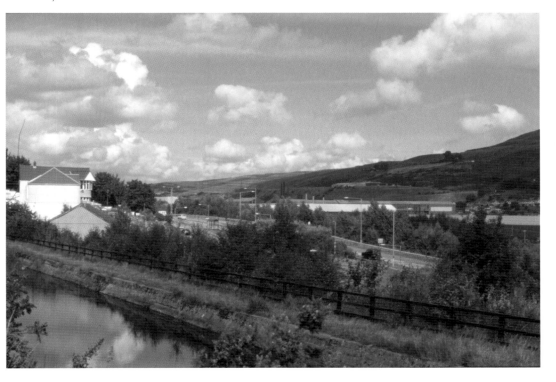

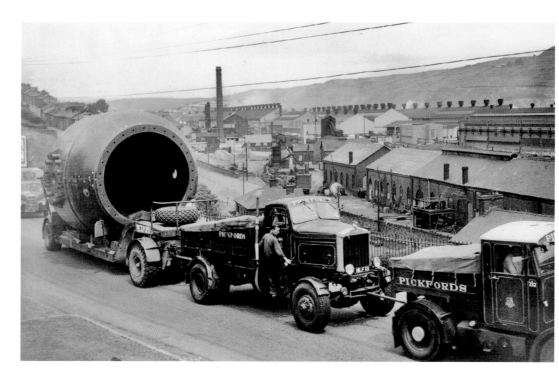

A New Converter

A converter being transported by road near Lethbridge Terrace, close to Garden City, in 1957 for Ebbw Vale Steelworks. Ysbyty Aneurin Bevan, the new hospital, is on this site in today's view; it was opened on 13 October 2010. Aneurin Bevan, Labour MP for Ebbw Vale (1929–60), was the founder of the National Health Service in Britain in 1948.

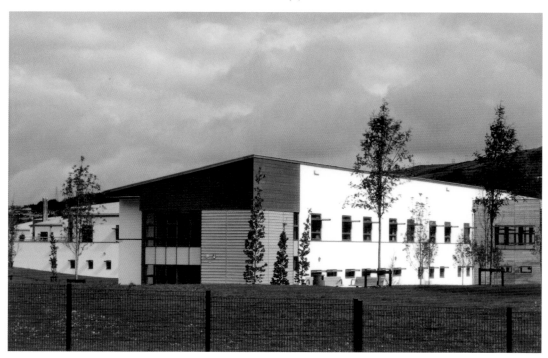

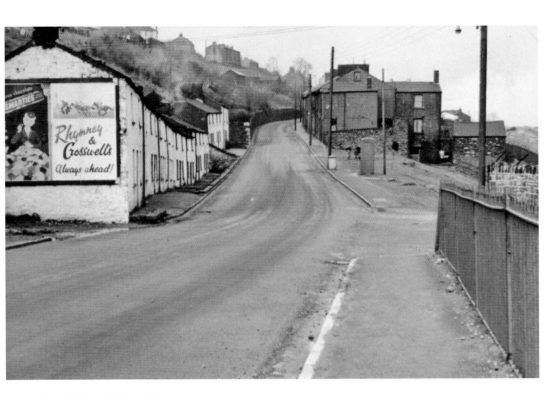

Victoria Road (North)

The view north from the west gate works entrance in 1952 shows Boundary Row and Victoria Road, which were demolished in the 1970s. The view north in 1999 shows that Victoria Road and Boundary Row are long gone; the Ebbw Vale bypass was built in 1974.

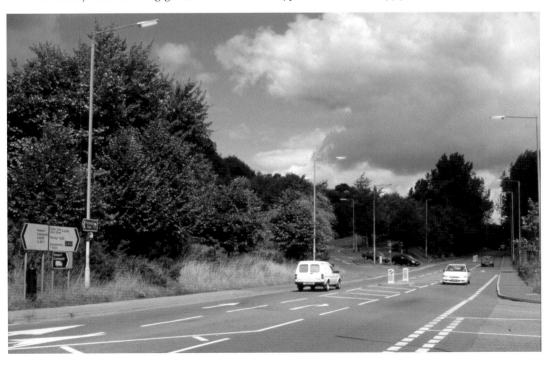

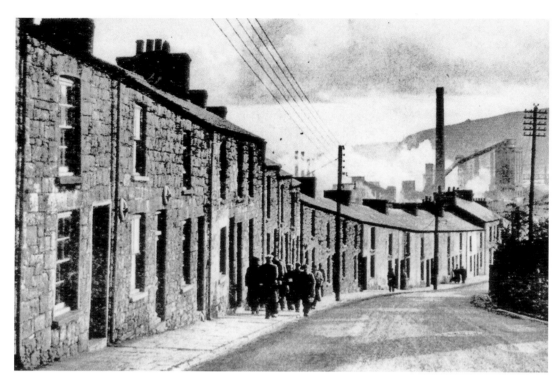

Victoria Road (South)

A southerly view of Victoria Road ('Gin Shop Hill') in the 1950s, with steelworkers changing shifts. Below, Ebbw Vale Steelworks in the early 1970s in wintertime, seen from the site of Victoria Road (demolished in 1972).

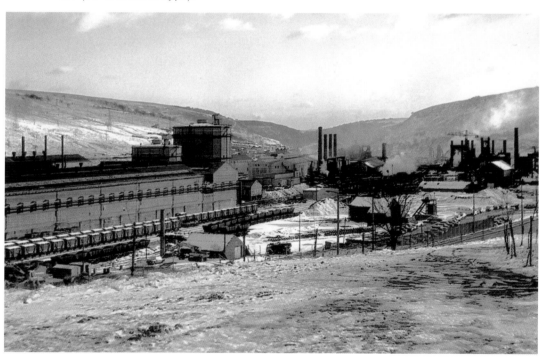

4. EBBW VALE

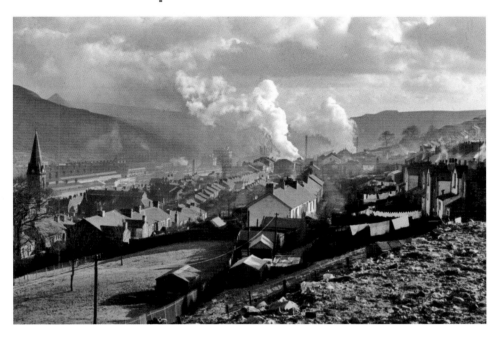

Ebbw Vale
Another rare colour photograph of a southerly view from Drysiog Street in the 1950s shows the constant pollution from the steelworks. The 1999 view north is from Drysiog Mountain Gate. Note Christchurch in both photographs.

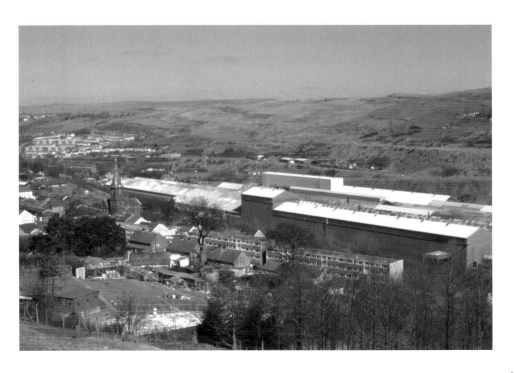

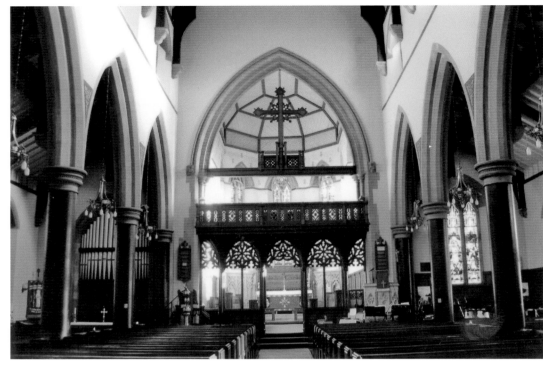

Christchurch

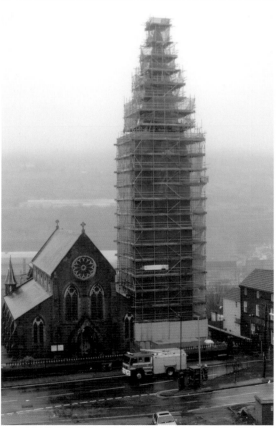

Christchurch, Ebbw Vale, was opened for worship and dedicated on 8 December 1861 by the Lord Bishop of Llandaff, the Reverend Alfred Ollivant, who called it 'the Cathedral of the Hills'. In 1882 the spire was added and in 1919 the four-dial clock was presented by Sir Frederick Mills in memory of his young daughter, Hilda, who had died suddenly. Sir Frederick Mills was chairman and managing director of Ebbw Vale Steelworks from 1899 to 1929. In 1937 a peal of bells was presented by Sir William Firth, who was instrumental in the rebirth of Ebbw Vale Steelworks in 1936 and was the managing director until 1940. His wife, Lady Firth, presented a silver chalice with rubies and a silver plate to his memory in July 1964. The photograph to the left shows Christchurch during repair work in 2003; a fire took hold in the spire on 3 December 2003 during this restoration period. The top photograph shows an interior view of Christchurch; the 150th anniversary will be celebrated in 2011.

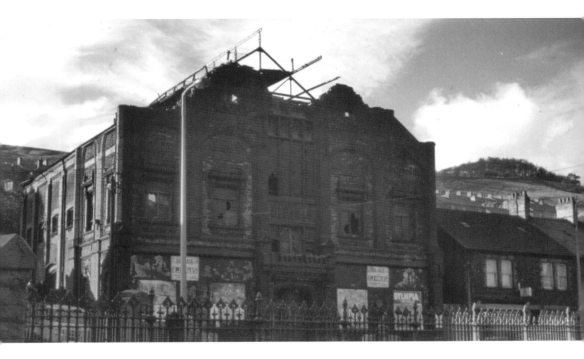

The Palace Theatre
The Palace Theatre (opposite Christchurch), was built in 1895 and closed in 1958. The 1972 demolition views are from the front and the rear of the building.

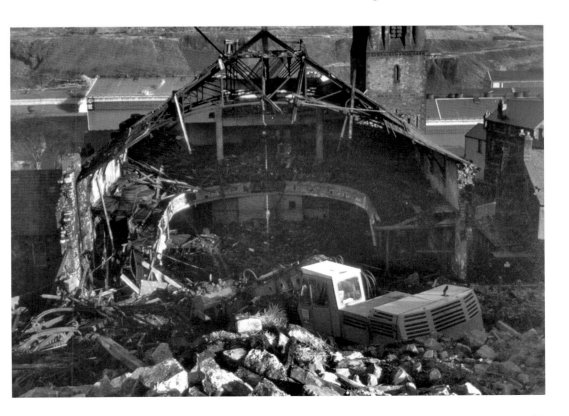

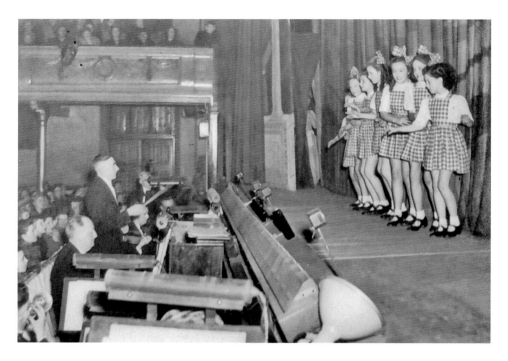

RTB Steelworks Pantomime

The Palace was the home of the RTB Works Pantomime in 1946–57. The stage was huge – in Wales, only the Swansea Grand was larger. These views show the stage, orchestra pit and balcony during *Babes in the Wood* (December 1949) and *Mother Goose* (December 1953). From 1958 the pantomime moved to the RTB Lever Hall until 1983. (*Photographs from albums donated to the Ebbw Vale Works Archival Trust by Mary Langford.*)

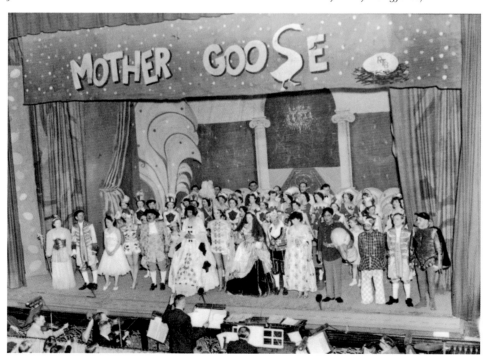

Bethcar Street (Upper)
A view north down Bethcar Street in 2004 shows its pedestrianisation; the 2009 view below shows the new colonnade.

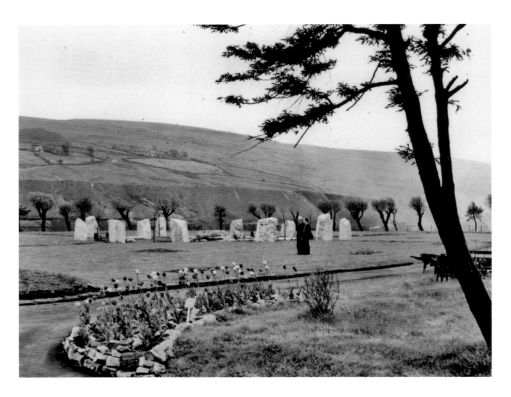

Gorsedd Stones

The Royal National Eisteddfod of Wales Gorsedd Stone Circle, erected in June 1957 in readiness for August 1958. There are twelve stones making up the circle and dais. The 'Maen Llog', or Logan Stone, is set in the centre of the Gorsedd Circle. Today, Aldi and McDonald's cover the same site.

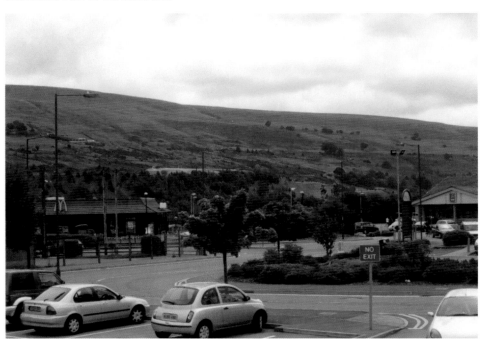

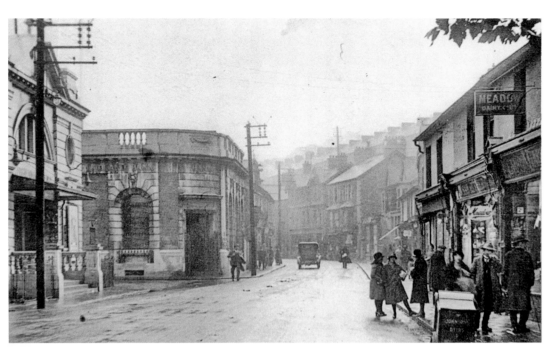

Bethcar Street (Middle)
A southerly view of the White House Cinema in the 1930s. Woolworths occupied the same site and was the main shop in Ebbw Vale for years; it closed its doors locally and nationwide around 31 December 2008.

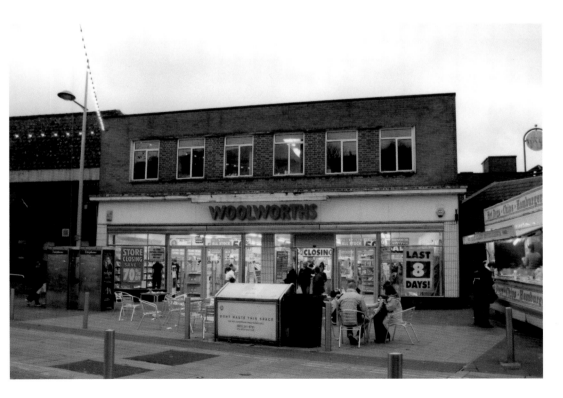

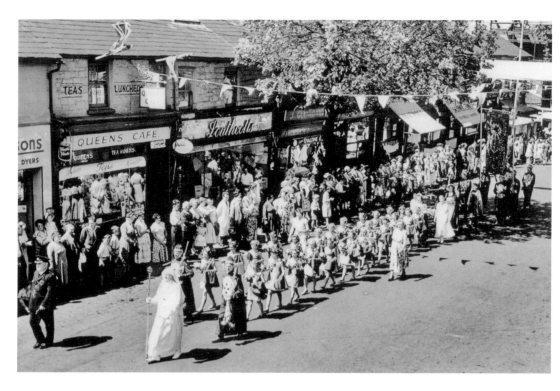

Bethcar Street (Lower)
This northerly view from Woolworths shows part of the Royal National Eisteddfod Proclamation Ceremony's procession, including floral dance girls. It took place on 19 June 1957 at the Gorsedd Circle on the drill ground. A 2004 view illustrates pedestrianisation.

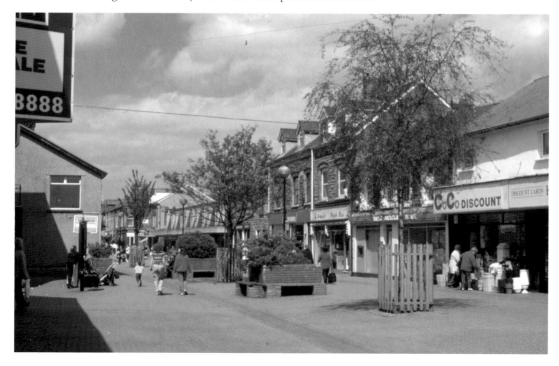

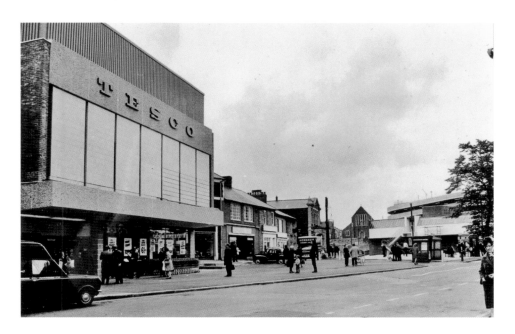

The Crossing (I)

The Astoria Cinema site was initially purchased by Tesco, who then moved to the old Sychffos site by Cemetery Corner. The site is now occupied by the Picture House pub. The new steel town clock, erected in 2009, is called *Echoes* and was designed by Marianne Forrest. The text at the base of the sculpture reads, 'The Ironworks owned all the collieries, people worked hard in two very dangerous industries ... The old steelworks went on forever into the distance, you could see the coal buckets hanging from extraordinary heights.' The text on the arm of the sculpture reads, 'The surviving workforce worked as well as they always did with quality at the forefront until the bitter end. A proud workforce right up to closure.'

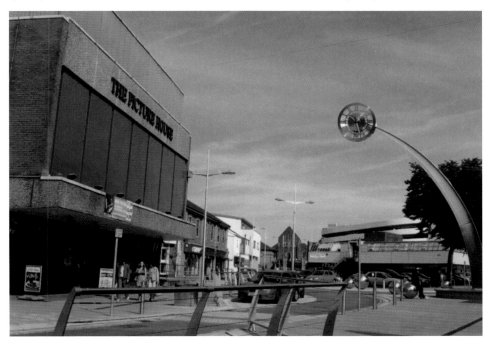

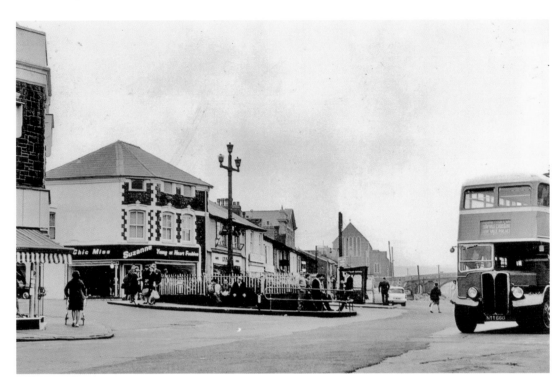

James Street
A northerly view of the Crossing, James Street, West End Chapel and a double-decker bus in early 1960. Below, a view of the trailer bringing the Gorsedd Stones from Trefil Quarry to the drill ground via the Crossing in 1957, with the Astoria Cinema in the background.

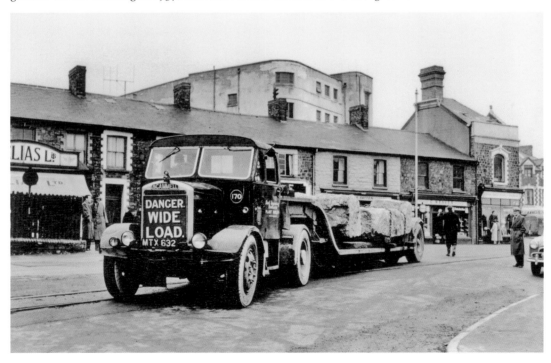

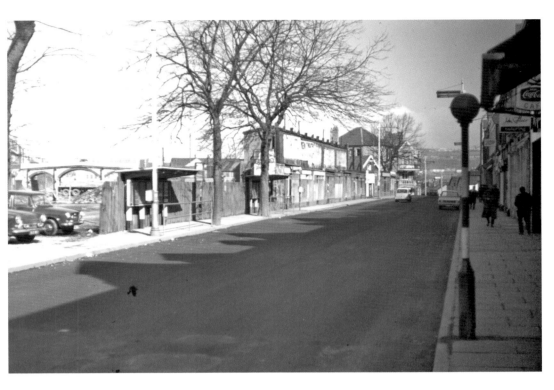

Market Street (I)

An early 1960s view north of Market Street with shops boarded up and cinema adverts above, next to the disused railway station. Peacocks and a multi-storey car park dominate the scene today.

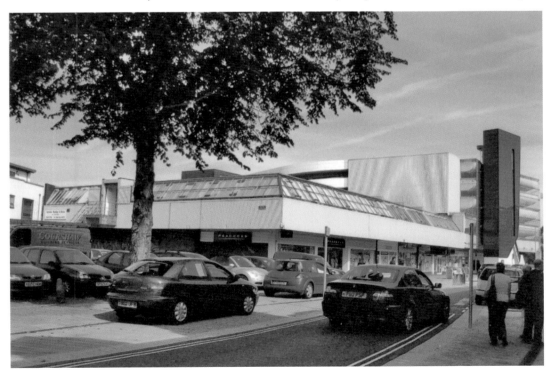

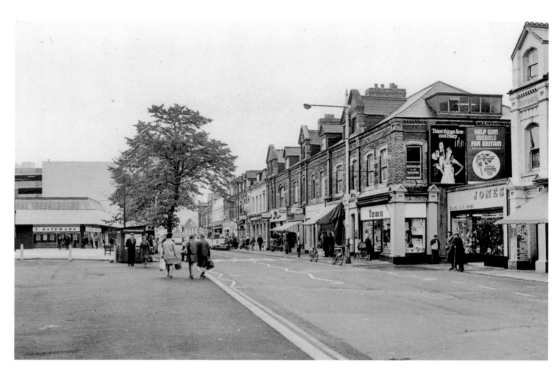

Market Street (II)
Market Street north-west from the Crossing in 1974, after Ebbw Vale's redevelopment; below, today's view.

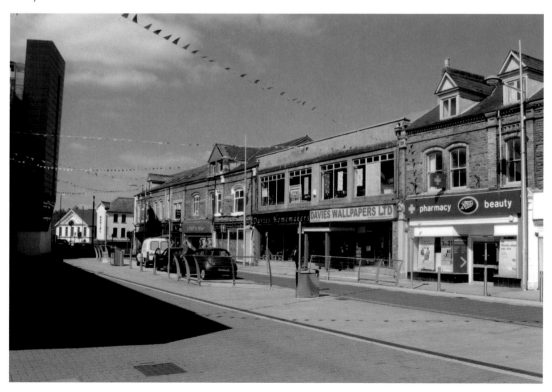

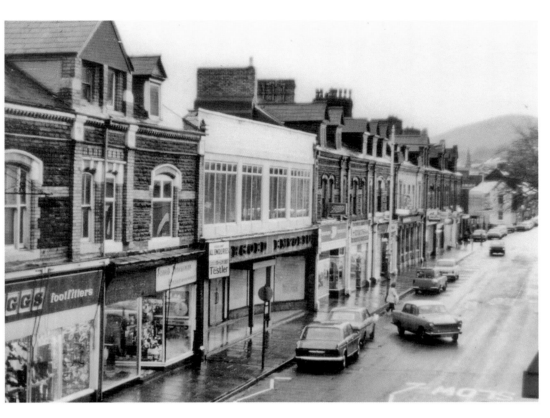

Market Street (III)
Southerly views from the multi-storey car park in 1974 and 2010. Christchurch spire can be seen in the background of both photographs.

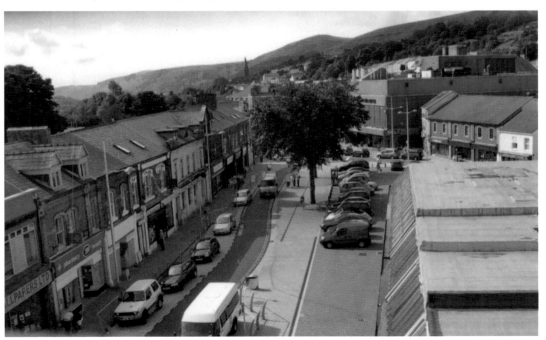

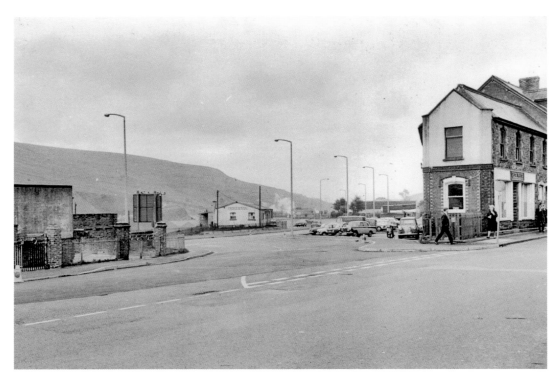

The Crossing (II)
Robert Price Yard, Prole Printers, and the Red & White offices are shown in this south-easterly 1974 shot. Today's view includes the new town clock.

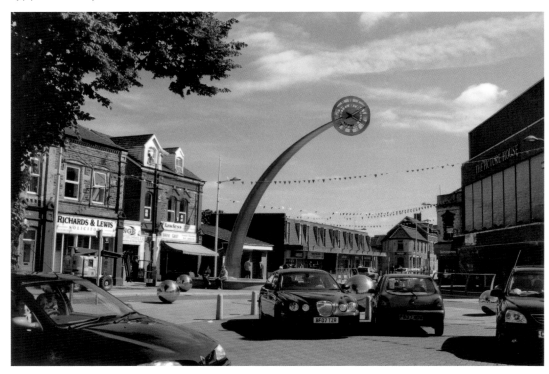

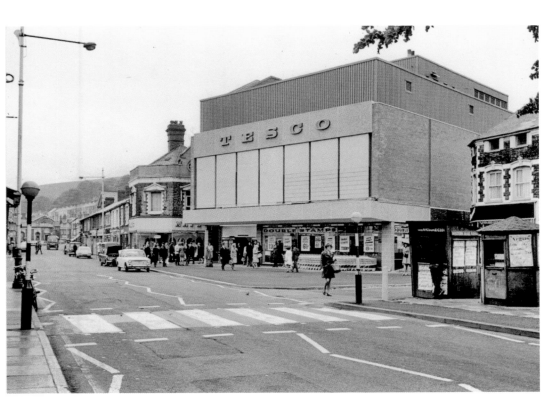

Tesco at the Crossing
The view south from Market Street shows Bethcar Street and Tesco; today the Picture House pub is on the same site.

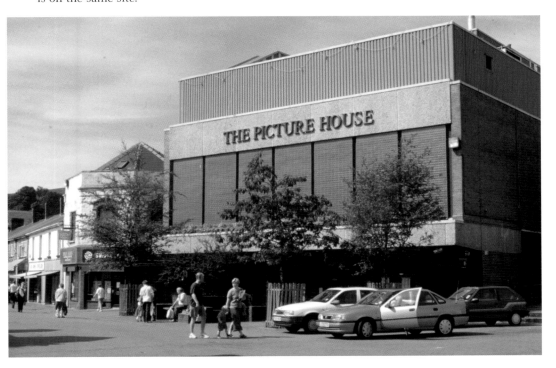

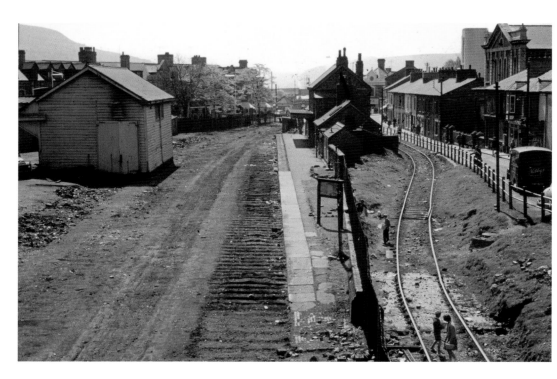

South to the Crossing

Another rare colour photograph from the early 1960s records a southerly view from the Tredegar Road railway bridge towards the Crossing of James Street (right), the disused Ebbw Vale High Level railway station (LMS), and Market Street (left). Today's view is of the multi-storey car park, which is on the site of the old railway station.

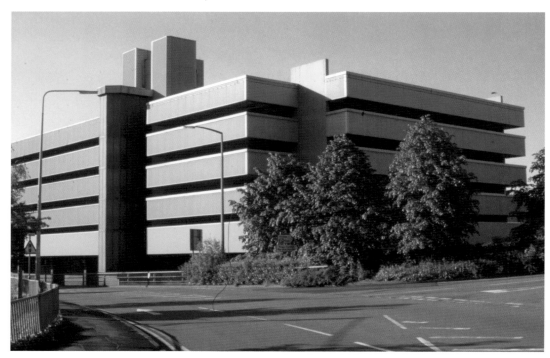

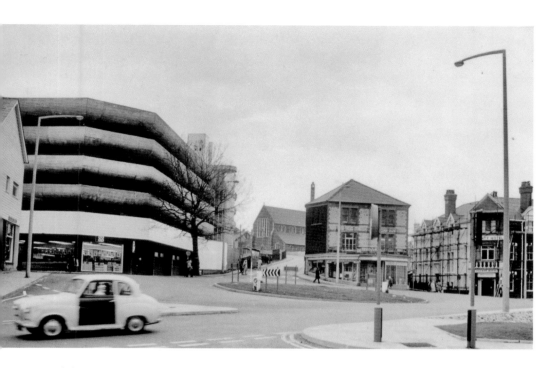

Roundabout and Multi-Storey Car Park

The town was redeveloped in 1974 and a multi-storey car park was built. The county buildings were demolished in 2004 and the County Hotel was destroyed by a fire on 14 December 2008. The Plaza Cinema, which also stood near this site, was demolished in March 1970. The view below is from 2010.

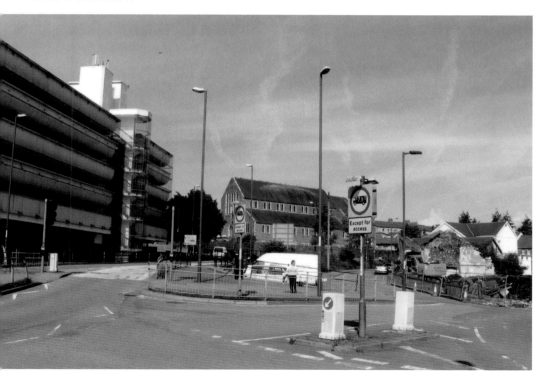

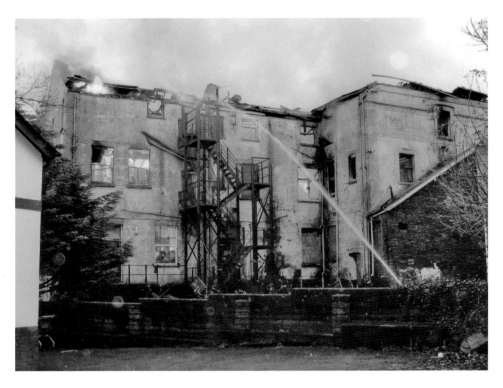

County Hotel Fire
The severe fire that took hold of the derelict County Hotel on 14 December 2008 completely destroyed the building. The Ebbw Vale fire crew are in attendance. Libanus Church lies opposite.

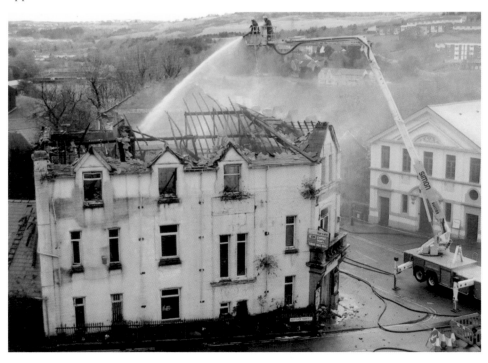

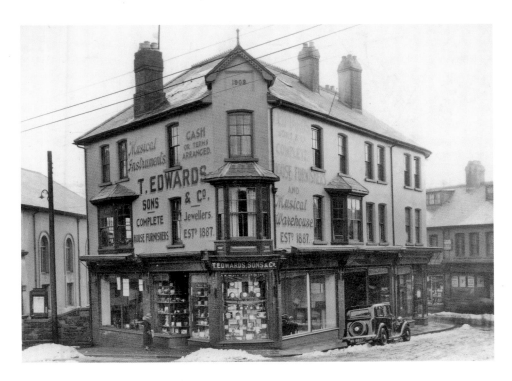

Libanus Church

T. Edwards & Sons was a well-known and well-established trader (*c.* 1930s) next to Libanus Church; Daniel took over this site. Below, Sir Ian Botham is pictured on his Valleys Walk on 4 October 2003 for the Noah's Ark Appeal, which raises money for the Children's Hospital for Wales.

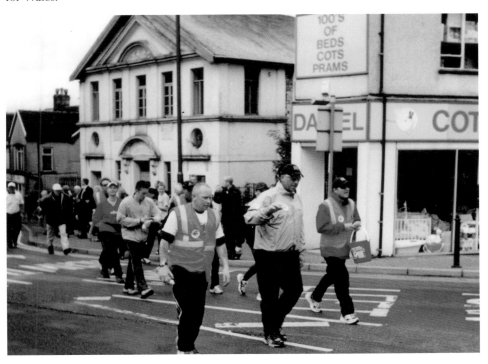

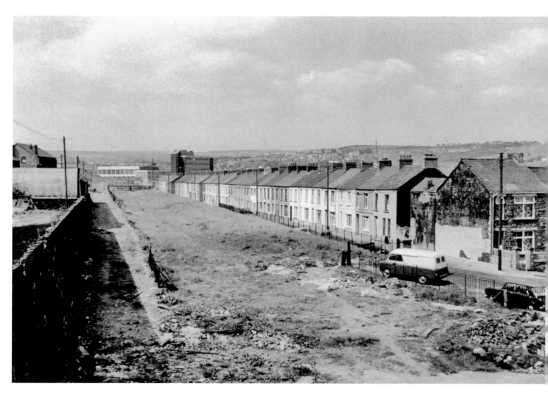

Western Terrace

A northerly 1960s view of Western Terrace, after the railway line (LMS) was removed. This is now the main road out of Ebbw Vale. Central Cars, next to the County Hotel site, is pictured.

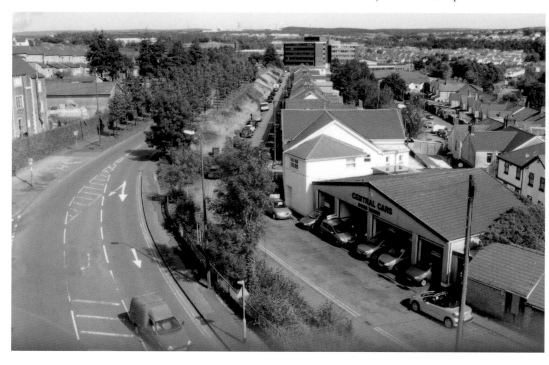

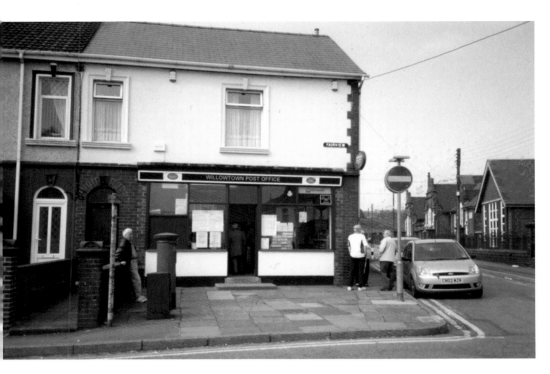

Post Office and School, Willowtown

Willowtown is an area of Ebbw Vale. This post office was closed on 12 May 2004. On 16 September 2007 Willowtown School, which was not in use at the time, was engulfed in flames and destroyed.

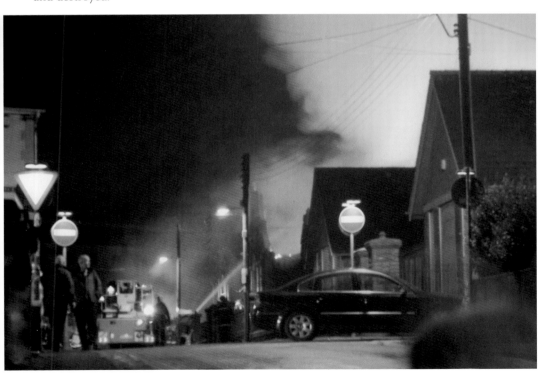

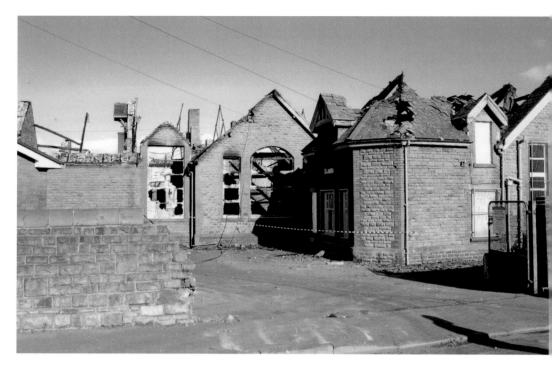

Willowtown School

The aftermath; Willowtown School is a shell. The new Willowtown Community Primary School (Trehelyg) was built on the Brynheulog Brickworks site, next to the old school, and opened on 7 March 2007.

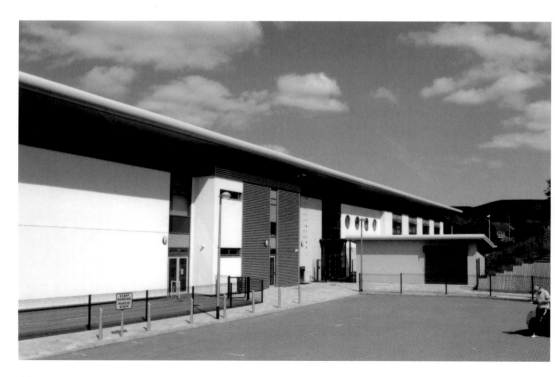

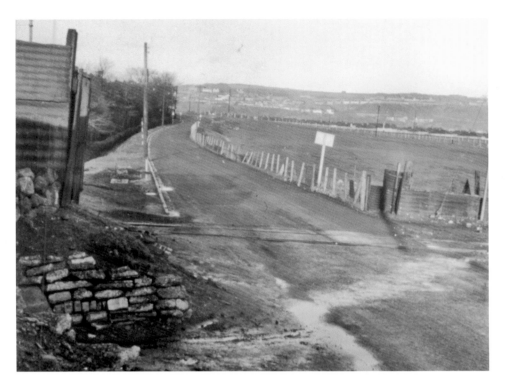

Cemetery Corner (1)

A north-easterly 1952 view of Cemetery Corner shows the mineral line from Trefil Quarry. This line passed through the Crossing in Ebbw Vale and led to Ebbw Vale Steelworks. The 2004 photograph was taken from the same viewpoint.

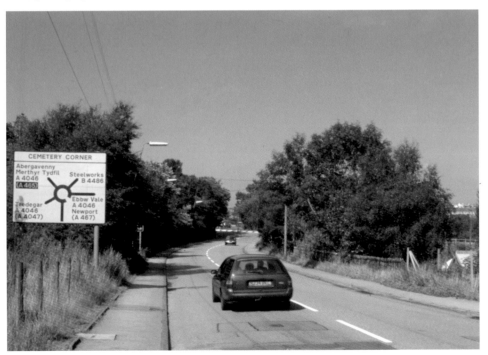

Cemetery Corner (II)

A wilderness in 1952 with Pit Road, now College Row. Below, the 2010 view from the roundabout shows Coleg Gwent. Further up on the right is Ysbyty'r Tri Chwm, which opened on 26 July 1996.

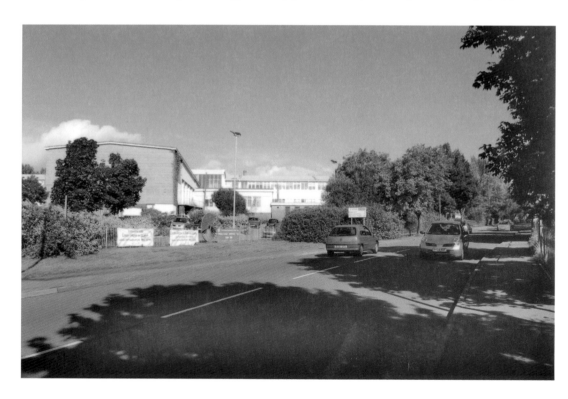

The Gantre

The southerly view from the old LMS railway bridge towards the Gantre on the left in 1952. Today, the Ebbw Vale fire station is on the left (as pictured); the council offices and leisure centre are on the right.

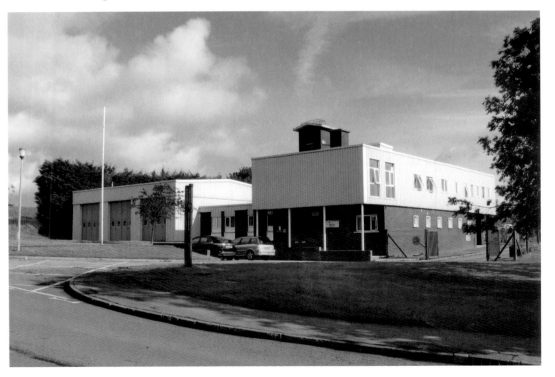

Tesco

The old road out of Ebbw Vale, looking north towards Cemetery Corner, in 1952. Tesco is now on the left. Again we see Sir Ian Botham in 2003 on his Valleys Walk for the Noah's Ark Appeal.

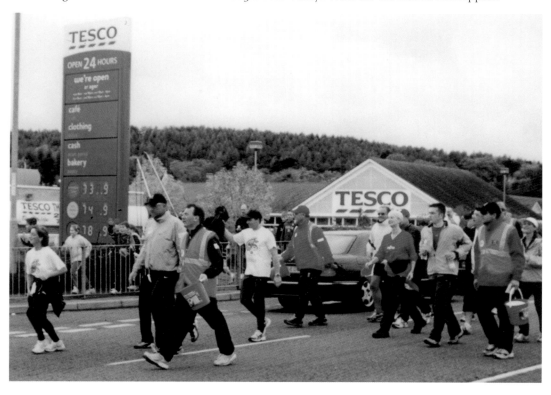

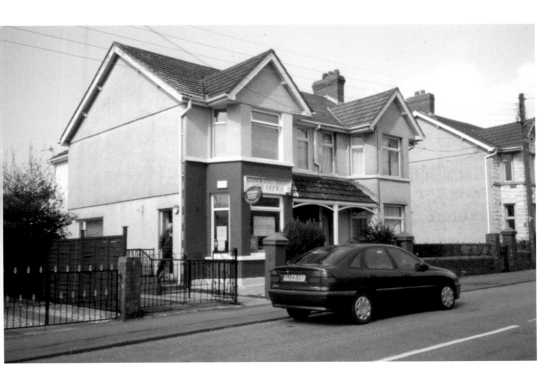

Badminton Grove

Badminton Grove Post Office closed on 26 April 2004. The Ebbw Vale County Grammar School, on reorganisation in 1974, became Glanyrafon Junior Comprehensive School, which closed in July 1998.

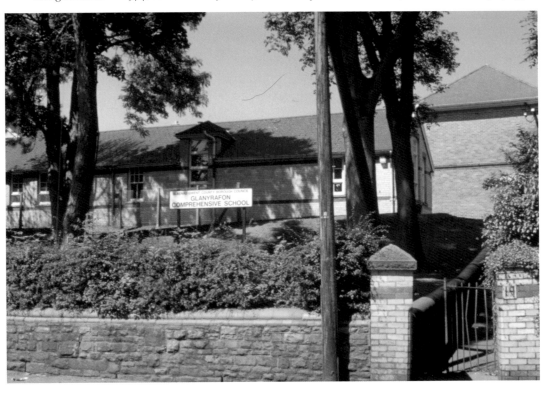

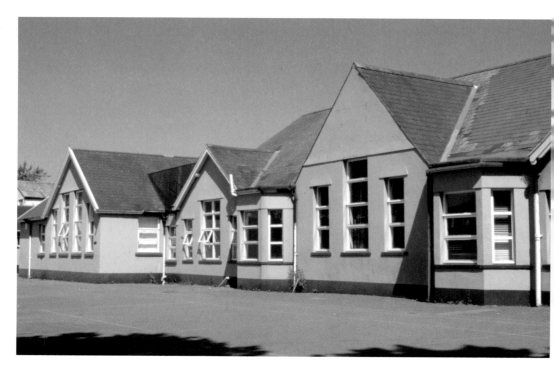

Ebbw Vale County Grammar School
A view of the original grammar school, which was opened in September 1899. Part of it was destroyed by fire on 26 November 1971, when many valuable school records were destroyed. Today it is the site of College Mews housing estate.

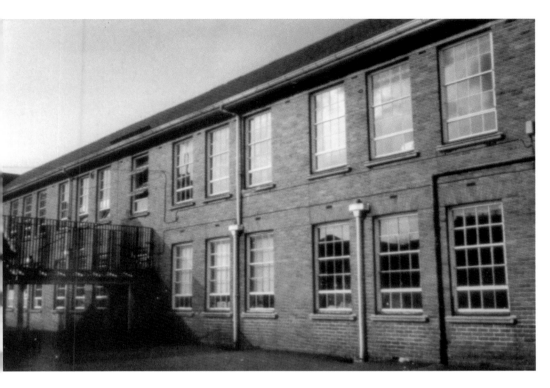

Science Buildings

A new science block was added in 1938; it was renamed 'the old block' when another was added in 1960. Here it is photographed before closure in 1998.

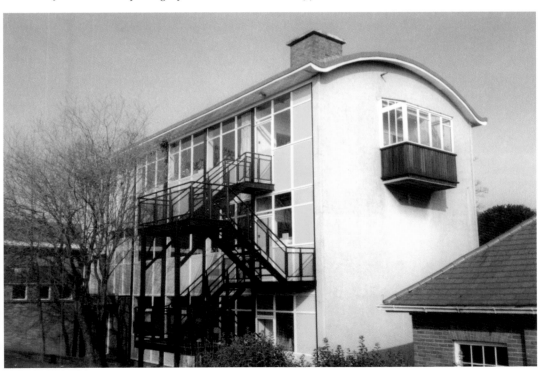

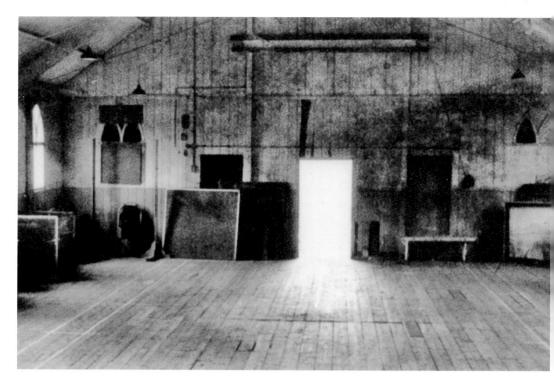

Assembly Interiors

At the same time in 1960, a new assembly hall replaced the legendary 'Tin Tab' (the Tin Tabernacle, above, was re-sited here from Tirzah Church in Cwm). The honours board can be seen on the left. The lower photograph was taken before the hall's demolition in 1998.

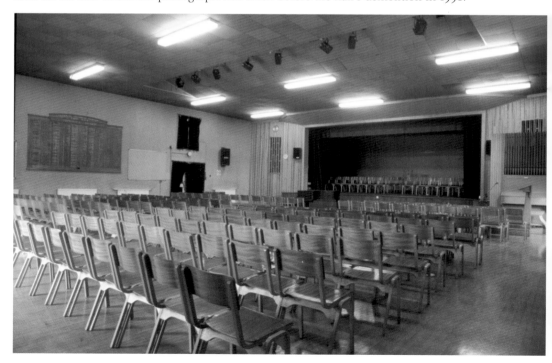

5. BEAUFORT & GARNLYDAN

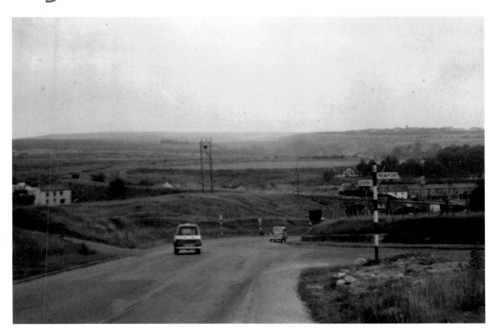

Carmeltown

A view in 1964 of the road leading to Dead Slow. The 2009 view shows the development of the Rassau Industrial Estate and the road north, where the old LMS railway viaduct was, to the Heads of the Valleys Road roundabout.

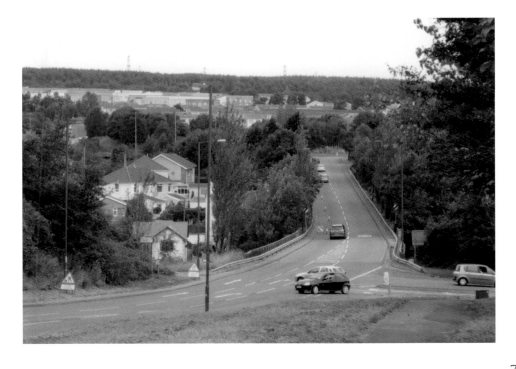

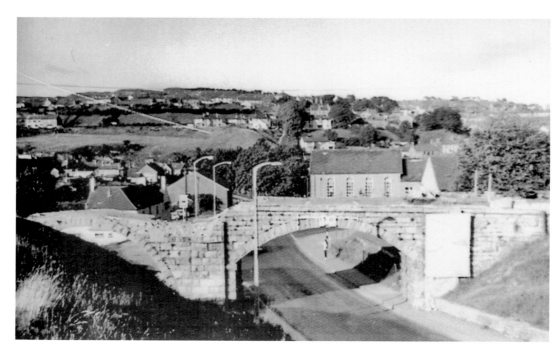

Rhyd-y-Blew

Dead Slow was a notorious traffic black spot. Here part of the old railway viaduct is being dismantled in 1965, with Barham Chapel pictured behind. The viaduct was near the Rhyd-y-Blew pub, where the row of trees is today.

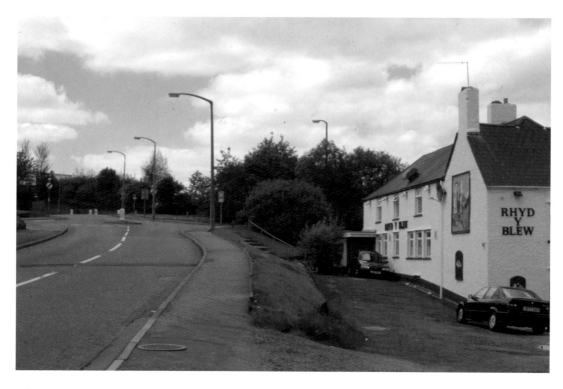

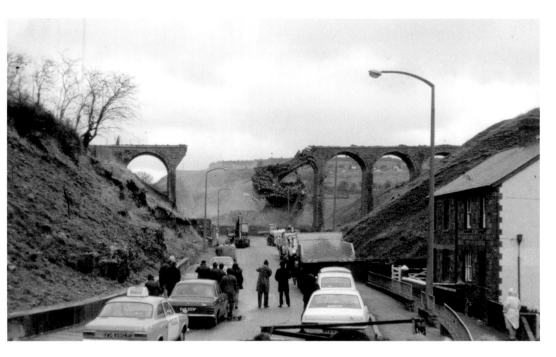

Cwm Carno (Lower Cwm)

Cwm Carno was spanned by another railway viaduct carrying the LMS line from Abergavenny to Merthyr; it was blown up on 13 January 1972 after six attempts to bring it down. Garnlydan can be seen in the background. Now the Heads of the Valleys Road passes over Cwm Carno.

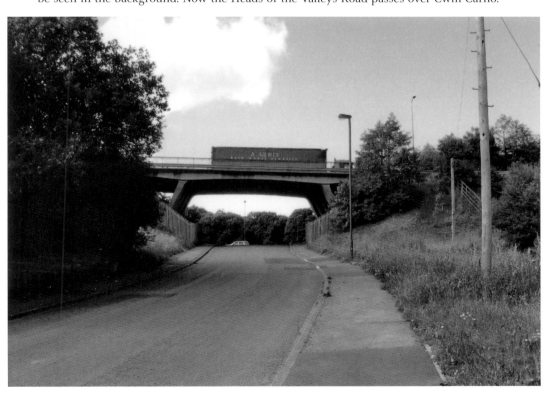

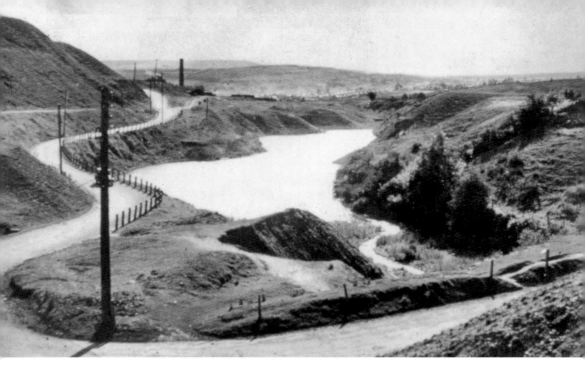

Garnlydan Pond

A westerly view of Garnlydan Pond in 1964, with Beaufort Brickworks on the left. Today's view is from the footbridge over the Heads of the Valleys Road, with Rassau on the right.

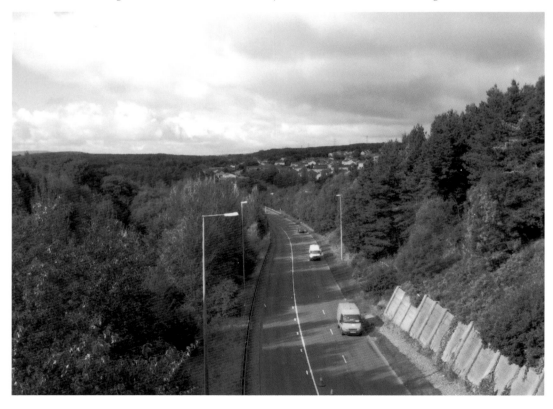

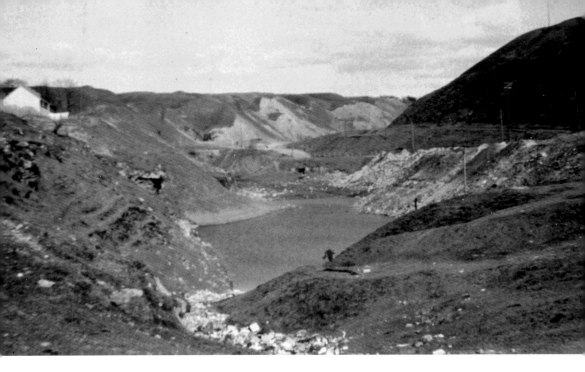

Heads of the Valleys Road
An easterly view of Garnlydan Pond, with Garnlydan on the left in 1964. The 2010 view is from the footbridge over the Heads of the Valleys Road, with Garnlydan on the left.

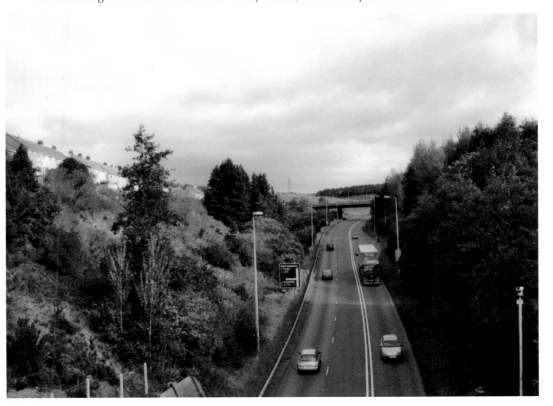

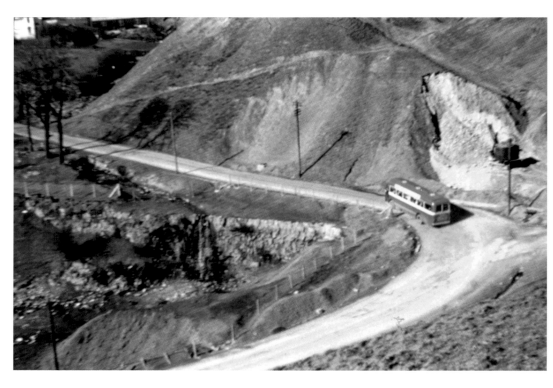

The Road to Garnlydan
The old road to Garnlydan in 1964, and a 1966 view of the newly-built bridge over the Heads of the Valleys Road.

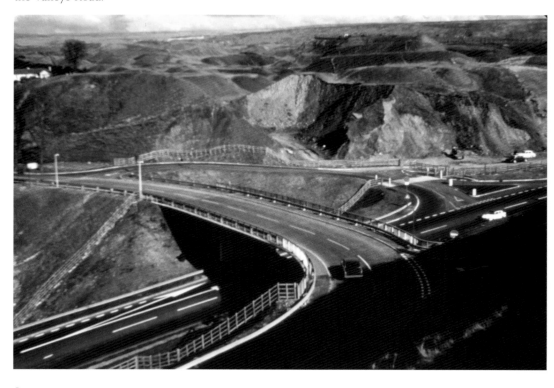

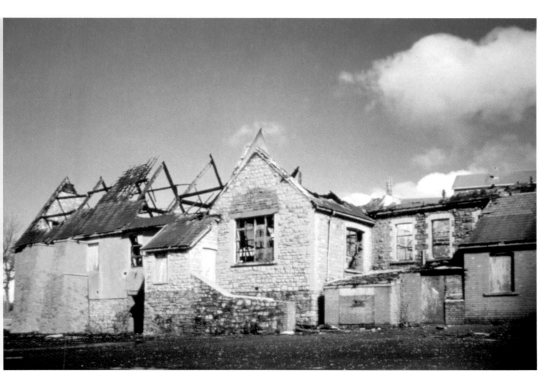

Beaufort Hill School
The remains of Beaufort Hill School, which celebrated its centenary in 1974. It closed in 1991 and was ravaged and destroyed by a fire on 27 March 1995. Heol Siloam is now on the site. The new Beaufort Hill School opened in 1991 on a different site.

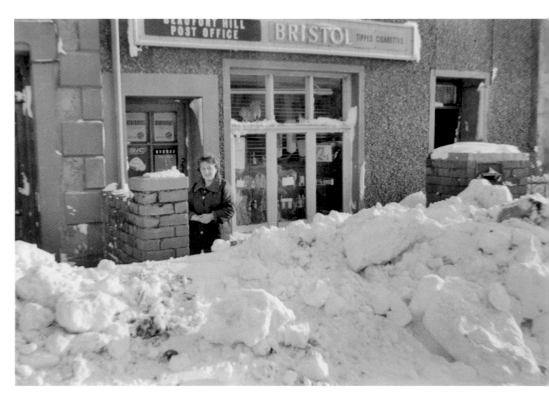

Beaufort Hill Post Office
Beaufort Hill Post Office in the heavy snowfalls of March 1965 (the worst blizzard since 1947), with post mistress Miss Pollie Williams. The post office closed on 14 April 2004.

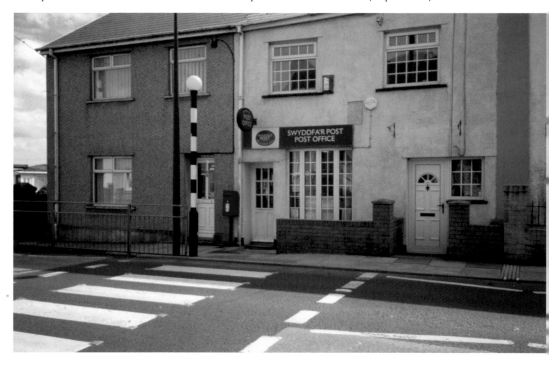

6. PONTYGOF, THE WORKS SITE & TYLLWYN

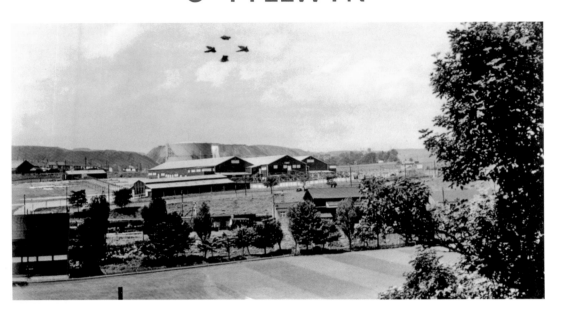

Gantre Site
The Gantre Pit was the site of the Royal National Eisteddfod of Wales on 4–9 August 1958. Today the site is occupied by the Blaenau Gwent Council Offices and Ebbw Vale Leisure Centre. The Gorsedd Stone Circle, after removal in 1967 from the original siting at the drill ground, is now opposite the leisure centre.

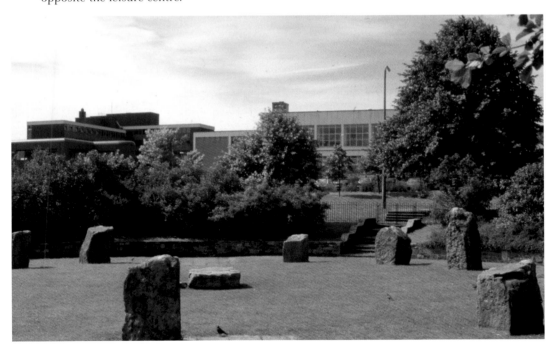

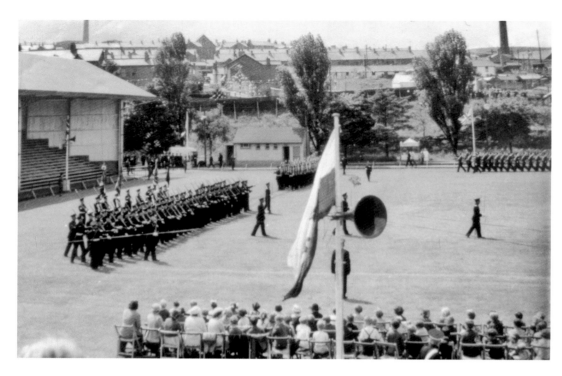

Eugene Cross Park

25 July 1958 also saw the Duke of Edinburgh present new colours to the 1st Battalion of the South Wales Borderers and the 2nd Battalion of the Monmouthshire Regiment on the Welfare Ground, which was renamed Eugene Cross Park after a local benefactor, Sir Eugene Cross, in 1974. The photograph below shows the new stand and Blaenau Gwent's civic and leisure centre.

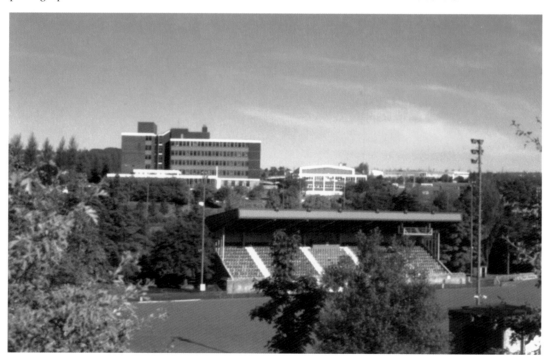

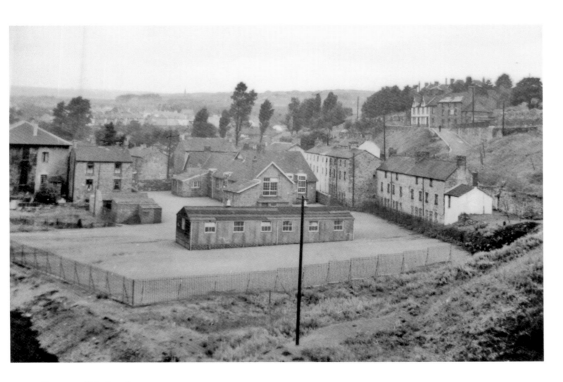

Pontygof School
Pontygof School and Pontygof Row in the 1950s. Below is a celebration of the 150th anniversary of the school in June 2008. Everyone is dressed in Victorian costume for the occasion. This is Class 6 with teacher Mr Dewi Owen.

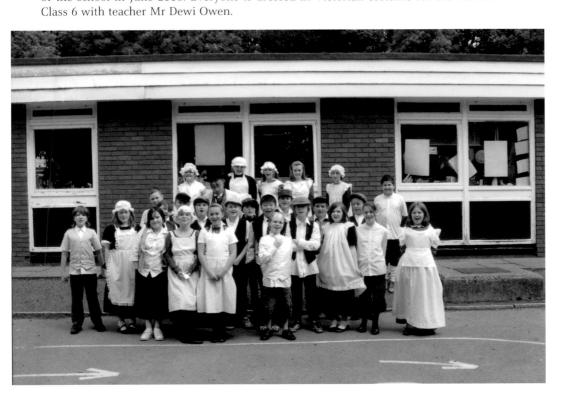

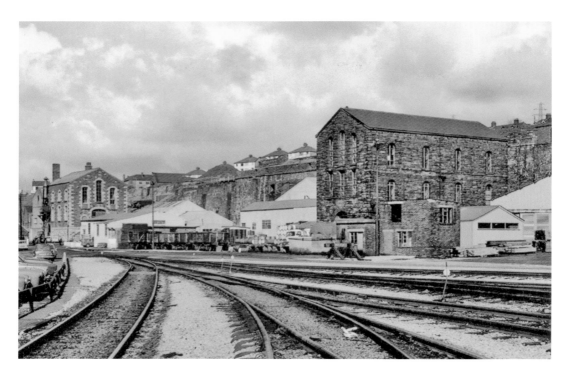

Cae Ffwrnais

The original Ebbw Vale Furnaces were built here in 1790 in what was called the 45 Yard; the photograph shows the Darby Engine House. The demolition of the buildings was in the 1970s. The retaining wall remains on the right in the lower picture, with the new housing of Cae Ffwrnais covering this site today. Newtown is above.

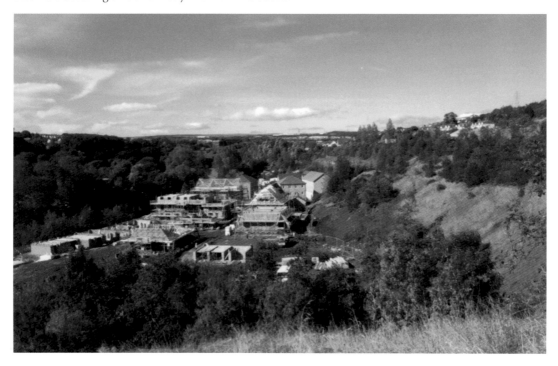

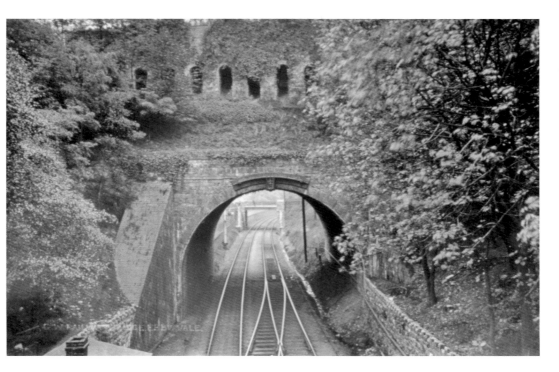

GWR Line to Newport

A view south in the late 1890s of the 1813 Newtown Bridge from the Ebbw Vale Low Level station (which was demolished in 1973). The northerly 1977 view shows that the rail line has been taken up to be replaced by a new road. The road bridge would soon be demolished.

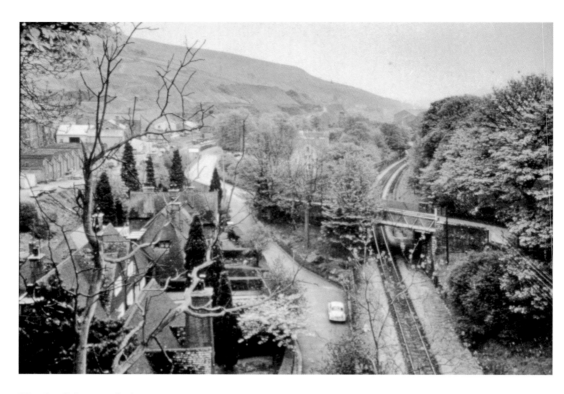

The Croft by North Gate

The southerly view from the Newtown 'Big Bridge' shows The Dingle and The Croft; the railway line is being removed. The 1999 view shows the new road and The Croft, by the north gate of Ebbw Vale Steelworks.

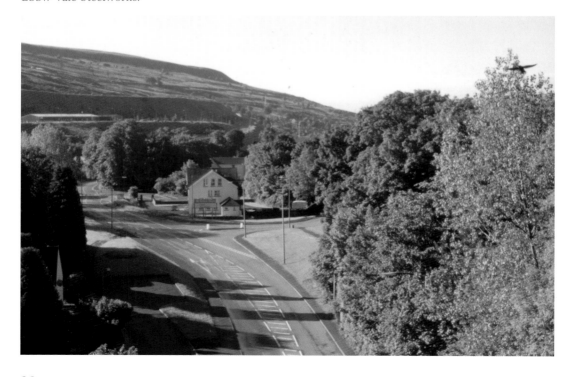

The General Offices

The renovation in 2008 of the works' General Offices, a Grade II-listed building built in 1915, including a clock tower. Texts above the clock dials read 'Time fleeth away without delay' and 'Take time while time is for time will away'. The Gwent Records Office is relocating here from Cwmbran in 2011. The Ebbw Vale Works Archival Trust will also be returning to its original home.

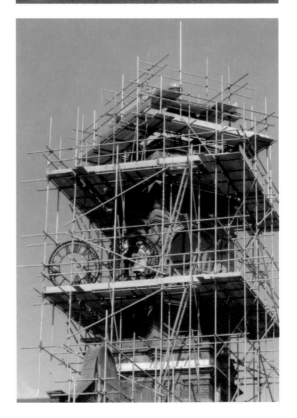

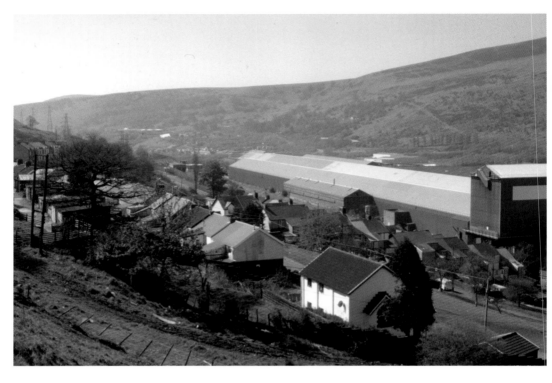

Ebbw Vale Works – Panorama (I)
A panoramic southerly view of the Hot Mill at Ebbw Vale Steelworks in 1984; below, a photograph
taken from above Tyllwyn in August 2010, during the National Eisteddfod of Wales.

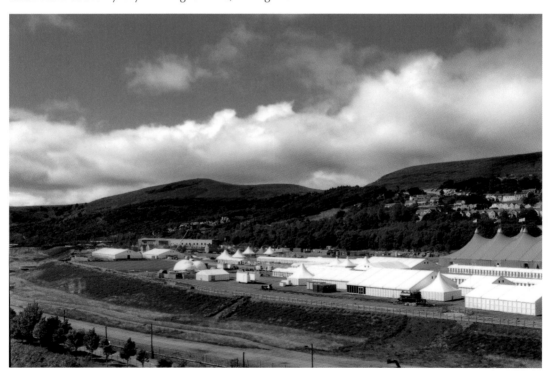

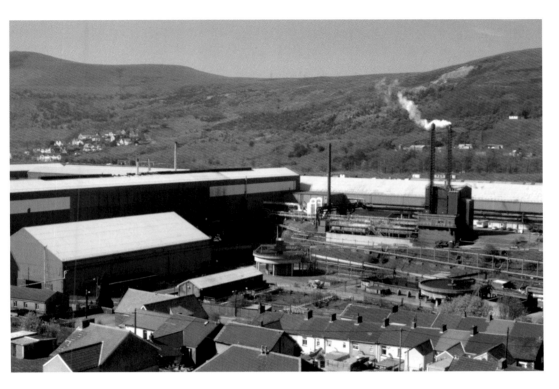

Ebbw Vale Works – Panorama (II)
A continuation of previous view, here west of the Lurgi plant and pickler in 1984; Garden City is on the left. Below, demolition of the pickler opposite Tyllwyn on 31 March 2004.

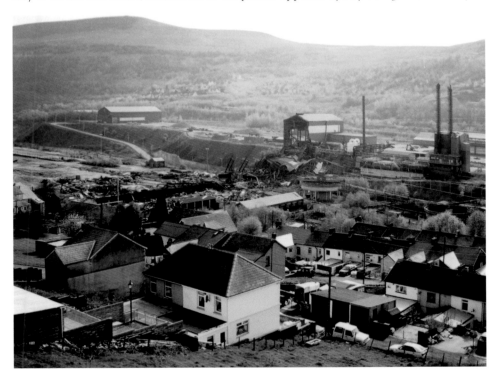

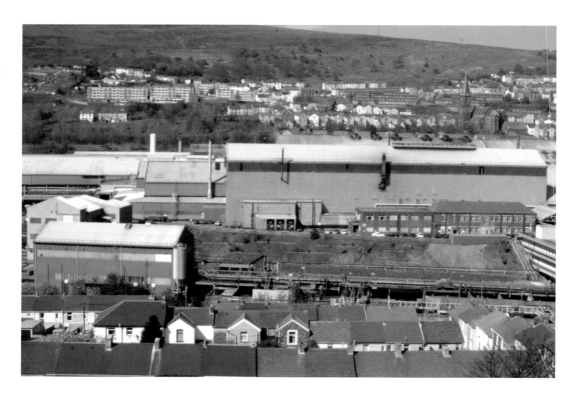

Ebbw Vale Works – Panorama (III)

A 1984 view of the steelworks' cold mill and effluent plant; the National Eisteddfod of Wales erected its Pink Pavilion on the same site in 2010. Note that Christchurch in Ebbw Vale is in both photographs.

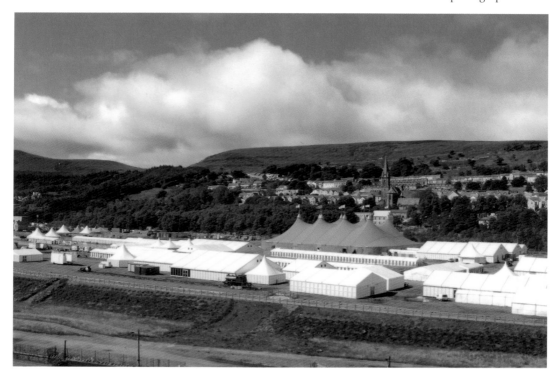

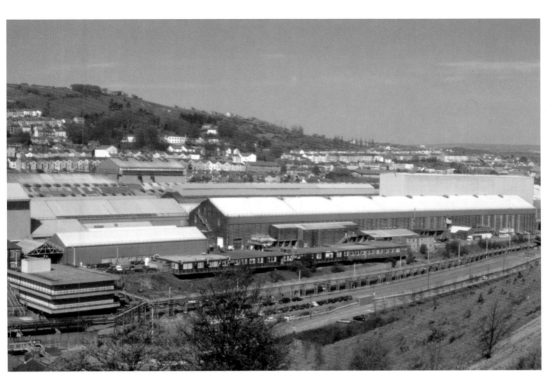

Ebbw Vale Works – Panorama (IV)
A north-westerly view of 1984 shows the cold mill, the metallurgical laboratories and Bath House; below, the National Eisteddfod of Wales in August 2010.

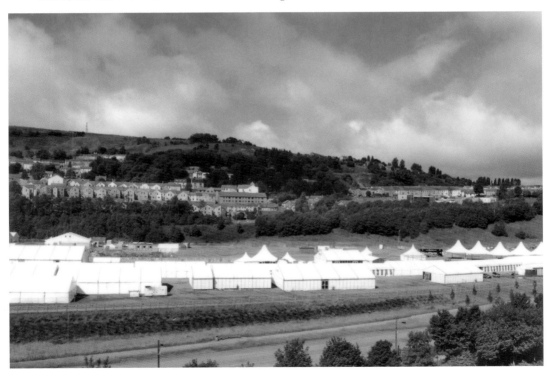

Tyllwyn

A view from Ebbw Vale Steelworks shows Tyllwyn School, now home to Ebbw Vale Town Band. Tyllwyn Post Office is now closed and Pretoria Terrace has long been demolished. Today's view from Eastville Road shows the new Ysbyty Aneurin Bevan, opened on 13 October 2010. The Domen mountain and Garden City are in the background.

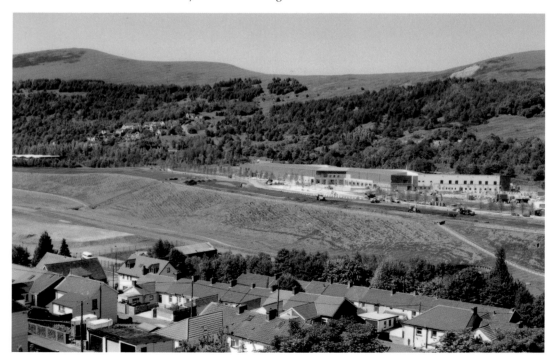